A HUMUMENT

TOM PHILLIPS

A HUMUMENT
A TREATED VICTORIAN NOVEL

THAMES AND HUDSON

Published in the United States in 1982 by Thames and
Hudson Inc., 500 Fifth Avenue, New York, Ne-
w York 10110

Published by arrangement with Edition Hansjörg Mayer

Library of Congress Catalog Card Number 82-50860

ISBN 0-500-27284-0

Printed and bound in West Germany by Staib & Mayer,
Stuttgart

AUTHOR'S PREFACE

Hoping that the reader would want to meet
the book head on I have put the introduction
at the end.

AUTHOR'S NOTE

Self-evidently this work owes an incalculable
debt to William Hurrell Mallock, the unwit-
ting collaborator in its making. If supplemen-
tary fame accrues thereby to his name, may it
compensate for any bruising of his spirit.

Still for Jill

volume And
side I shall lie,
bones my bones

A HUM███████UMENT.

A HUMAN DOCUMENT.

INTRODUCTION.

THE following
sing
I
a
book. a book
of art

of

mind,
art

and
that
which

he
hid
reveal I

has not lived badly, it means only that she has not lived
at all."

My companion fixed her eyes on me with an odd look of
inquiry.

"Do you remember this?" I went on. "There is one
thing and one thing only which Marie Bashkirtcheff seems to
wince at recording, had it been a thing, she says, which passionately
sullied her whole life. Do you remember what it was? It
was a single kiss on the forehead which she gave to an un-
interesting boy. As if this, who can think it, sullied her,
a childish trifle like that, knows no more of a woman than a man
can know of partridge-shooting who feels disgust at a sports-
man by a splash of mud on his shoes.

"Tell me," said the countess, with a slight access of irony,
"how deep in the mud must a woman walk before you
considers her progress interesting?"

"He doesn't want her," I said, "to walk in the mud at all.
When you ask that question you are running away with a
word. What he wants her to experience is not the dirt of
life, but the depths. The woman we are speaking of had only
paddled in the shallows, and she thought herself drowning
when a ripple broke over her ankles. I confess I am irritated
by this priggish self-delusion; and yet, after all, it is that
very quality that, if she had ever really lived, would have
made her Journal such a revelation. I wish," I went on, as
my thoughts more or less ran away with me, "I wish that
this woman, with all her moral daintiness, had been swept off
her feet by some real and serious passion. I wish that with
soul and body she had gone through the storm and fire; that
what she had once despised and dreaded had become the
desire of her heart; and that she had found herself rejecting
like pieces of idle jewellery the principles on which once she
prided herself as being part of her nature. What an astonish-
ment and what an instruction she would have been to herself
during the process! Think how she would have felt each
part of it—the degradation, the exaltation, the new weakness,
the new strength, the bewilderment, the transfiguration,
the—well—I don't know what, and she
would have given us a human document
or two.

possess a certain something, and I am thinking whether I will show it to you. Tell me," she went on with a laugh, "do you think you would care to see it?"

To this riddle only one answer was possible. "Anything which you think worth showing me I am sure I shall think worth seeing."

"Ah," she replied, "but you will have to do more than see it. This is something which you will have to pore and puzzle over, and if you don't take enough trouble about it to thoroughly try your temper, I shall discover how apathetic you have been, and consider you have abused my confidence. You are perhaps prepared to hear that what I speak about is a collection of manuscripts."

"Are they yours?" I asked.

"Only," she said, "in the sense that they are my property. They were left me by the writer, who died a few months ago. She was a beautiful woman, and you know something about her; but not much, or I can't tell what would have happened to you."

"Go on," I said; "this is indeed interesting."

"If you really meant," she replied, "what you were just now saying, it ought to be far more interesting to you, than you have the least reason to suppose. Shall I tell you what the manuscript is? It is an imaginary continuation of Marie Bashkirtcheff's Journal, in which she is represented as undergoing the exact fate you were wishing for her. I suspect, too," she continued, "that it is something more than that. Indeed, I am certain that it is; but you must read it first, and I will talk it over with you afterwards. If you care to have it, it shall be sent to your room to-night."

Countess Z—— was as good as her word. I was tempted for a moment to think she was even better, when, on going up-stairs to bed, I saw lying on my table, not what I had pictured to myself—a small unpromising packet, which I could have held in my hand, and put with my pocket-handkerchief under my pillow, but a great folio volume bound like a photographic scrap-book, the sight of which filled me with dismay. When, however, I opened it, I was at once reassured and puzzled. It was a scrap-book in reality, not in appearance only; and its bulk was explained by the fact that its leaves were of thick cartridge-paper, and that the manuscript, whose sheets varied in size and appearance, had been

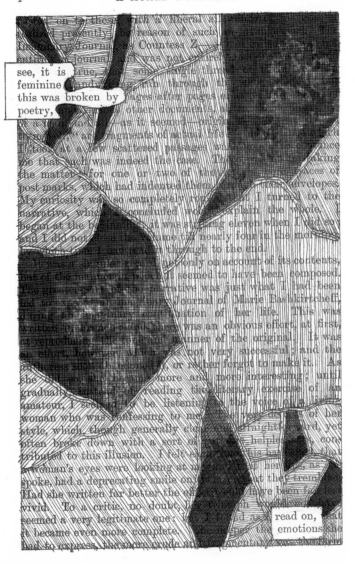

... on to these ... with a liberal ...
... presently ... reason of such ...
... Journal of Countess Z—
... Journal ... was not ...
... true ... some ... while I ... ed ...
... and ... th through ...
... ages after page ...
... other document ...
... as I seemed ...

see, it is feminine this was broken by poetry,

... fragments of actual life ...
... few scattered passages wa ...
me that such was indeed the case. Th ... aking
the matter ... for one or two of the ... ces of
post-marks, which had indented the ... nvelopes.
My curiosity was so completely rou ... I turned to the
narrative, which ... concluded wo ... plain the whole.
began at the be ... it was striking eleven when I ... so
and I did not ... the ... nearly four in the mor ...
... I had rea ... through to the end.

It was a ... only on account of its contents,
but of the ... w ... seemed to have been composed.
The gr ... arrative was just what I had been
had to ... Journal of Marie Bashkirtcheff,
... ation of her life. This was
written ... was an obvious effort, at first,
at reproduc ... nner of the original. It was
an effort, how ... not very successful; and the
authoress s ... or rather forgot to make it. As
she ... more and more interesting; until
gradually ... reading the literary exercise of an
amateur, I seem ... to be listening ... the voice of a
woman who was ... fessing to me ... of her
style, which ... generally cle ... traight ... rd, yet
often broke down with a sort of ... helpl ... con-
tributed to this illusion. I felt as ... this ...
woman's eyes were looking at ... her ... as
spoke, had a deprecating smile on ... at the trem ...
Had she written far better the eff ... ould have been ...
vivid. To a critic, no doubt, ... h wo ...
seemed a very legitimate one; ... I fo ... as
it became even more complete. ... th ...
had to express, the more crude ...

read on, emotions

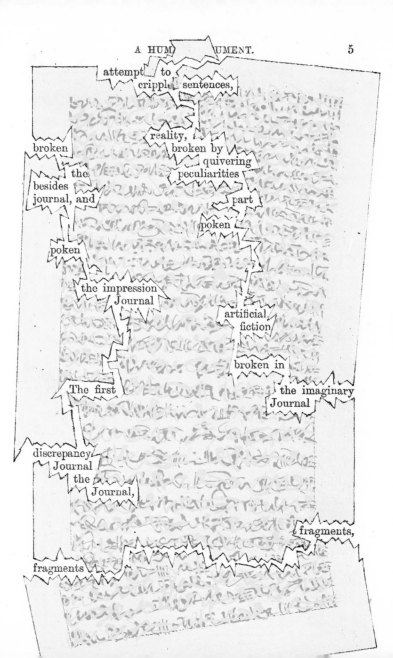

attempt to
crippl. sentences,

reality,
broken broken by
 quivering
the peculiarities
besides
journal, and part

 poken

poken

the impression
Journal

 artificial,
 fiction

 broken in

The first the imaginary
 Journal

discrepancy
Journal
the
Journal,

 fragments,

fragments

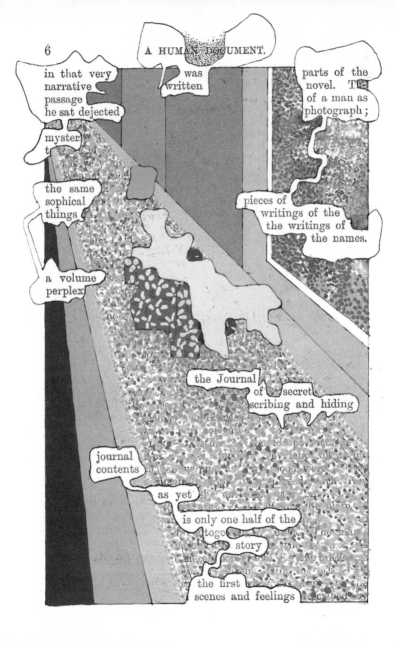

in that very
narrative
passage
he sat dejected

was
written

parts of the
novel. Th
of a man as
photograph ;

myster
t

the same
sophical
things

pieces of
writings of the
the writings of
the names.

a volume
perplex

the Journal
of the secret
scribing and hiding

journal
contents

as yet

is only one half of the

story

the first
scenes and feelings

her in a ... which a woman could not have described them ... if they had not been part of her own actual life; and yet, on the other hand, ... said also, would any woman, if they had been, have had the courage to describe them? There is another supposition which once or twice occurred to me, and that is that though her whole story is true, it is the story not of the authoress, but of some other woman who had revealed it to her. I thought, you see, that though she might have shrunk from describing herself, she might yet have had nerve enough for a *post-mortem* examination of a sister."

"Your supposition is wrong," said Countess Z—— quietly. "It is her own story. She has changed, as you have observed, the names of places and people; and also a number of other accidental circumstances. But so far as essentials are concerned, she has, to the best of my belief, never written a word that is not absolutely true. In that volume you have her life, and the life of another, turned literally inside out."

"And do you mean to tell me," I exclaimed, "that a woman of position and reputation, a woman too so sensitive as she must have been, and in some ways so extraordinarily innocent, would propose to publish such a ... confession about herself, with ... a mere pretence of ... a veil thrown over her own identity? There are things in that Journal which the most callous woman would hide."

"There is nothing in that Journal," said Countess Z——, "which a coarse woman could feel; and it is the sensitive women, and not the callous ones, for whom confession is sometimes a necessity. The veil, however, which you think so transparent, would really have been thick enough for every practical purpose. The hidden drama of which you have just seen the record was unsuspected by any one during the life time of the two chief actors, ... not likely to be suspected now that they both are dead. The very people who knew them whilst it was in progress, and indeed took unconscious parts in it, would never remember any account of it, be likely to connect it with the ... unless the ... places and localities were mentioned by their ... names ... by the authoress, slight as you may think them, would have been more than sufficient, supposing the book had been published ... to have preserved her secret ... her own acquaintances. And now," Countess Z—— continued, "I will

My sister and I arrived there the day after ye... heard of you from the housekeeper; and in parti... this. Of all **the pictures—** and they are ma... supposed to be **interesting—** you would look at no... **miniatures in my boudoir—three miniatures** ... the same woman. You couldn't be got away from them. "This is perfectly true," I said. "I see them distinctly still. The woman had a dress... **a different colour in each. There was a brown** dress, **a purple** ... **and a red one with white spots on it.** ... and what did her face mean? Was it guilt, or innocence, or passion, or aspiration? It was a sort of chameleon, and it meant them all by turns. That, at least is what I thought afterwards. I only felt at the time as if there were some philtre in the ivory.

"That," said ... "is the woman the Journal ... soul that I am no... to ... he continued, "I have ... Will you refuse ... **Come, toge...** ... down the ... library ... not be disturbed there, and we will look it over ...

I ... Something which I had no... before ... one of the ... and **turn inside** extracted ... paper. **"Look at this,"** she said ... between it. It is the dedica... tion which the author ... have prefixed to **her book;** and it will show ... you will be **fulfilling her** wishes if you ... and publish that **book as her** proxy."

What ... **out with surprise,** the w... merely a few lines ... recognized the hand ... perusal had made me familiar; but to ... now saw was written not in French ... but ... not in the English of a foreigner. The Countess ... the writer herself ... different time, which was **"Dedication"** "Consecration" ... which some ... well known to ... appropriated here ... only ... of this **volume." And** ... side **I shall lie,** ... **bones my bones** shall ...

to come back to you in death, to perpetuate in this book
neither your life nor mine, but that one single life into which
both our lives were fused. Were my power as great, equal
to my love, as a woman, that life should breathe in these pages
as it lived and breathed once in your now lonely body. I
would make it live, and it For nobody, caring
for perfect love name.
that I that I
proud .
were .

in witness of my love for you, every page

When I had finished reading this, I found my companion
looking at me with an expression of triumph at the interest
which was no doubt visible in my face. "I told you," she
said, "that you knew something of my mistress. Did I wasn't
I right in saying so? Even had I known it, I should have
been afraid to predict the consequences? Come," she went
on, "have I not won my cause? You cannot refuse me now
your heart is in the work already."

"It is," I said "I confess it. But still I foresee difficulties
—some of them specially incident to writing a book in
English. Give me to think the matter over and
to-morrow I will tell you what I can really do."

The difficulties which had first which first
engaged my attention were those . . . quite . . what
Countess Z—— had said, I thought might be experienced in
concealing the identity of the characters ing
day I pointed many cases out to her disguise
would be necessary than a mere name. On second
thoughts she was disposed to admit this; but, on the other
hand, she now went on to explain a . . . variety of things
which the manuscript only imperfectly indicate, such as the
position and circumstances of each mentioned
in it, and the precise extent to which of the
story escaped the notice of the society in the midst of which
they occurred. And the result was to convince me that she
had been substantially right from the first, and that the book
she was anxious I should attempt might, without any impru-
dence, be so written as to be minutely and literally true, not
only in all in point even of
the name of the would be most completely,
. . . . they were taken from the name change
in all

That book accordingly is now offered to the reader. As to
what the changes are which I have been obliged to make, I
cannot say more,

but

it is
a hum ument.

the
history viola

The characters

eve
ed
ople

stan
quent

sid

the
human nature general

operation
toge

condemned
to life,

this
good book
book for nobody.

rm

meaning
losing its meaning when
it follows
any picture of the
part of a
half of
a picture
details are not
representation

question
whether the book is
this—
it is as
If it is
and
exists in the
purposes it
does

moral immoral

moral

good people

have not been suppressed or altered.

moral

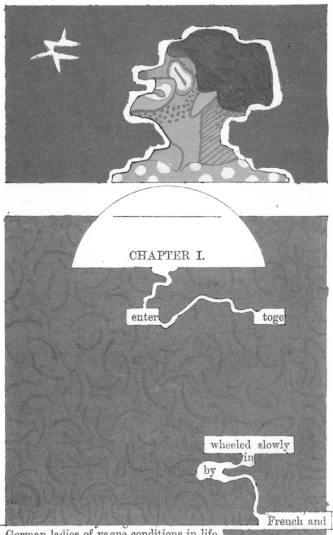

CHAPTER I.

enter toge

wheeled slowly
in
by

French and

German ladies of vague conditions in life,

dirty and pale
and

curious

curious spectator,

standing on
the scene

with dark, almond-shaped eyes,
teeth.

curled

his clothes,
loud.

He had, indeed, character ; he was engaged in what
was apparently a farewell conversation with a

highly satisfactory past ;

Only once

his toe

shot from his mouth, softly but with

a metallic

nasty little devil
I'm not your wife,
 , *chérie*," laughed the man,

flash

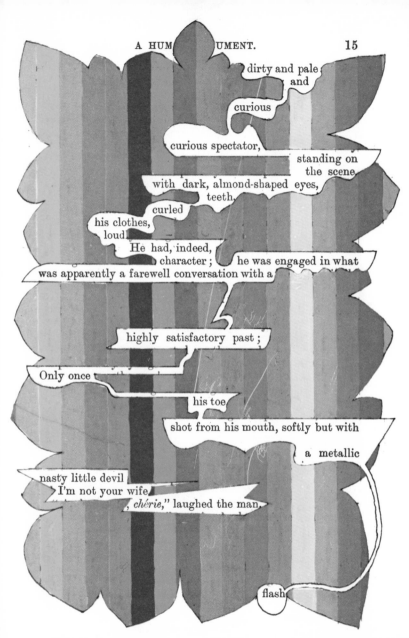

companion, from eyes that gleamed like a couple of sunlit window-panes, and said—" Are you getting jealous? I've taken a fancy to him already."

" Have you, darling?" replied the other. " It's a pity you're just too late. However, at all events, you can enjoy a good long look at him. Don't you see? They're coming to this carriage."

He stepped down from the balcony, and, resting his hand upon her arm, remained with her watching the group that was now approaching.

" This way, monsieur," said an official, full of importance. " The compartment reserved for you is at the far end of the passage. *Numéros quinze et dix-huit,*" he went on, to a valet and railway-porter, whom he ordered to enter first, with monsieur's various properties, including the despatch-box, which already had roused attention.

" Ah," said the lady, " I heard him speak. He's an English-man. You, my friend, would claim him as a compatriot, though your eyes and your name—myself I think both beau-tiful—would prevent this insular aristocrat from paying you back the compliment."

At this the gentleman made a little cluck with his tongue, as if rendering a tribute to the lady's delicate wit.

" See!" he said presently, " here your aristocrat comes again. He looks about him as if no one were worth considering. You know the English phrase that *a man gives himself airs.* There's a man who exactly shows its meaning."

" Don't tell me," replied the lady, " what a man means by his looks. This man means one of two things, or very probably both—that he thinks, *chéri,* very little of you, or that he's thinking a great deal about something or somebody else. Ah *Mon Dieu!*—but see!—something has roused him now."

The person who was the subject of all these observations, and who partly justified the tenor of them by a look of distinct good-breeding, together with an obvious inattention to the whole public about him, at this moment suddenly fixed his eyes on a fresh arrival visible at some little distance. This was a man, round-faced and fair-bearded, not distinguished-looking in the social sense of the word, indeed dressed in a way impossible in the world of fashion, but still bearing something in its aspect refined and suggesting intellect. What, however, had caught the attention of the Englishman, was not the

intellect
crippled, and

softened ;

" The lame one's a
critic "I saw his name on a label.
makes me ill, ducky, I shall go to him for a bottle of

art

art

art

art

art

venture on a piece of
sleep
I am going myself to

shut the door,
art

as

an
art curiosity, art surprise

begins to

rested in sleepy
gold initials,

thus

toge

That gentleman

in the passage
of

time

was, indeed, the

English—

the

Englishman's

"Have one of mine," said the lover, as he produced his own
—a gorgeous product of Vienna—and offered it distended to

the great Fanny

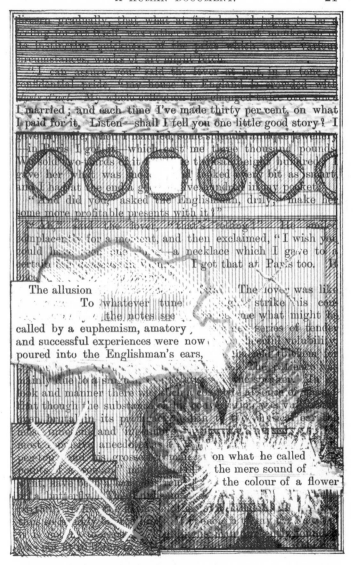

I married; and each time I've made thirty per cent on what I paid for it. Listen—shall I tell you one little good story? I

gave her what was asked bit as smart

"And did you asked the Englishman, drily, make her some more profitable presents with it?"

complacency for a moment, and then exclaimed, "I wish you could a necklace which I gave to a I got that at Paris too.

The allusion The lover was lik
To whatever tune strike his co
the notes see me what might b
called by a euphemism, amatory series of tende
and successful experiences were now
poured into the Englishman's ears,

on what he called
the mere sound of
the colour of a flower

his favour—that he was not gross like his companion. A

sight of a feminine figure, which was apparently in the act of

pleasure. "Has no one," he said to himself, "even a tolerably cleanly mind?"

—a medical student—to amuse me during my journey. Our

art of music... easily, and it
is bad morality excited to
unmanageably

... were ... by words, as
l'amour, ...
depraved and depraving ...
The novel of as indecent as
of profligacy. Mein Gott
would be as popular Parisian ...

... ... merely in science ...
... ... mild smile
... ... in Paris ...

FRENCH REVOLUTIONARY GE-
NERALS. Large crown ...

... mere pleasure ...

"You," said the doctor, laying his hand on his crippled leg.

practice in a small but rising watering-place; present is a landscape of fear and struggle."

"WHERE IS IT?"

fool. I have hope as well as ... hard work before me, but I have something worth

pointing to ... connected with invention.

Illustrations by George Cruikshank.

...y Illustrations by Phiz.

...y Illustrations by Phiz.

...ty Illustrations by Phiz.

...Illustrations by Phiz.

...y-three Illustrations by Landseer, Doyle, Maclise,

...ur Illustrations by George Cruikshank.

...ith Seventy-five Illustrations by George Cattermole

ARY EDITION.

...ION.

..., demy 8vo, 10s. each; or Sets,

...s, post 8vo, 8s. each; or Sets, £12.

... than half a philosophic ... even though ... self divine. ... at being sou ... at we were j ... fuence of lov ...

WORK WORK

...tiful? Because ... same somethi ... which love is one manifestation, and of which ... religion ... d longing for what is more than human, is another."

"Let us hope," said the Englishman, "that man's belief in the object of his religion is more accurate than his belief ... many of the objects of his love."

"In the present day," replied the doctor, "religion is

logical.

maintain this—that man is only human because of his longing

this—that life has lost all its hopes, and death none of its

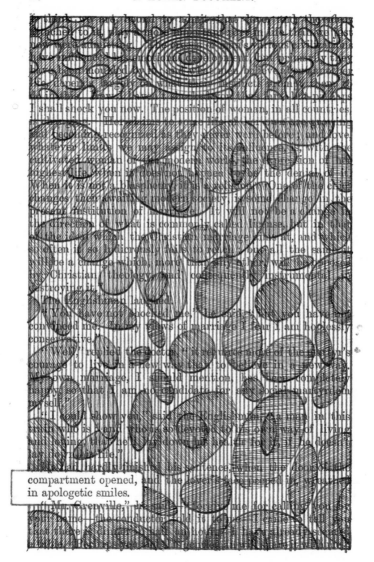

I shall shock you now. The position of woman, in all countries

compartment opened,
in apologetic smiles.

"That's the lover

The lover, and his companions, of the grape,

He happened to be taking from his pocket, a small photograph of an ancient English lover

a certain part of

the lover

was rigid

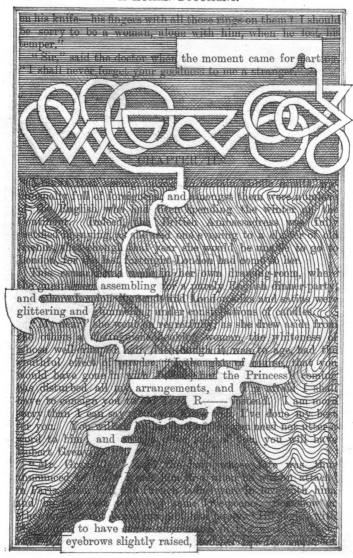

on his knife—his fingers with all these rings on them! I should be sorry to be a woman, along with him, when he lost his temper."

"Sir," said the doctor when the moment came for parting, "I shall never forget your goodness to me a stranger.

and amongst them were English who had been spending the winter

Ambassadress

year, she would be unable to go to London had come to her

in her own drawing-room, where English dinner-party

assembling

and glittering and under constellations of candles regretfully as she drew aside from woman, the whiteness of

the Princess coming has disturbed all my arrangements, and R—— am more

arrangements, and

R——

and

to have eyebrows slightly raised,

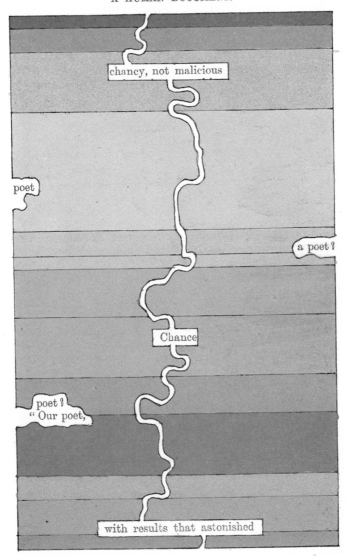

chancy, not malicious

poet

a poet?

Chance

poet?
" Our poet,

with results that astonished

Jackson goes home in July,
 tantin
cumula

A

wing-room love-poet,
 a

poetry
express

dreamer
man of action,
 his
every line
thinking about.
thinking about a woman.

stuff

love-poets :

"Julian,
 on poetry
nitz."
My dear

tired of

ming eye-glasses,

She was the daughter of England ; and

airs and graces in the halls of foreboding

Grenville

would for her

bang him On the bulbous face,

—that's Sir superior —that is Sir nod,

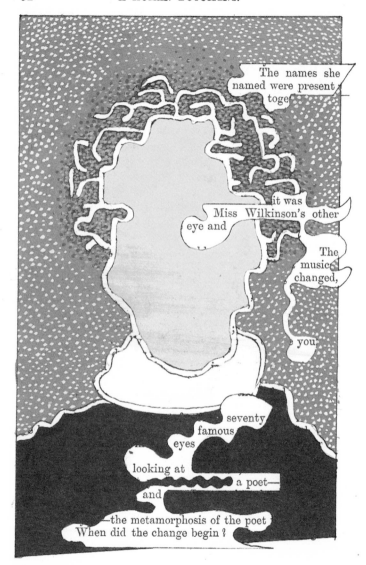

Grenville looked at her ... like ... of a man who honestly hates being the hero of his own conversation; but Lady Ashford was at once so ... and so fascinating that she had soon ... from ... when she asked for.

he had ...
when first ...
two necromancers, love ...
coloured it with colours, and filled it with objects of ambition, which ...

your sight, ... you now consider realities. Let me ... you happened not to be rich, and the ... that came home to you was the want of some more money. Accordingly you began to dabble in what you deserve as business, and you found your wits were far sharper than you expected. You did not, however, make your fortune in the first few weeks, and you were beginning to think that real fortune was a dream. Then you succeeded, ... into a stream of success — a real success indeed, such as you see ... in the city, for it gives you a sense ... not of having any of those ... Now you ... like ...

I want ...

... great pleasure. Fully ... you have succeeded in anything ...

Lady Ashford looked ... "Grenville," she answered, "... find? You have the opinion of ... other people know you have. You are ... though you have not yet satisfied ... in your position is success in its most ... and our host saying, as he went in to dinner, ... that he never had known so rapid a rise ... always a figure of some interest in society ... of a ... you are beginning to make a stir in it. ... I told ... the night before you entered the drawing room. You cannot pretend you were unconscious of the same thing yourself. Well," she said, sighing, "listen to this. I was told long ago by somebody who ought to have known, how nothing is so sweet to a man

softly

like hay-stacks. They sawplause—that it makes him feel as if
shortly to occupy, once the to rise on wings. The dawn of fame
others. Saints and scenes of love. Once upon a time I used
time, were daubed on the self. I want you to be frank with
me, and tell me your own experience."

been for some china pipes chave me expose myself, I *will* make
boots, they would still have some sense of success in me, something like what you mention; and I suppose it pleases me.

Yes, yes, of course it does. I am going to be quite honest
with you. I have so long thought and felt to so little purpose,
that there is something exhilarating in the knowledge that I
am now about to act; and in the hope that I shall not, as I
began to think I should, pass through the world leaving no
mark behind me, having done nothing, and having been
nothing. But that's not all. I am also conscious of a
certain fuss being made about me. I am ashamed to mention
the little trifles I am thinking of; and yet I confess that they
have the same effect on me which a glass of champagne has
on a man who has long been tired. But as to feeling as if I
were going to rise on wings—no, Lady Ashford, I can't follow
you there. My wings by this time have hardly a feather left
on them, though once they were plumed with illusions bright
as a bird of Paradise. And as to the dawn of fame being
like the day

"Well?"

"As to t

love like t

an impulse

it back again

Lady Ash

and then s

day. Let us put all our talk about ambition and success aside.

FIRST DIVISION. Till the time of
King David. Demy 8vo, 14s.

SECOND DIVISION. From the
Reign of David up to the Capture of Samaria. Demy 8vo, 14s.

THIRD DIVISION. From the time
of Hezekiah till the Return from
Babylon. Demy 8vo, 14s.

waiting for.
philosophy.

the Golden Age is
on the fiddle.

reality
music

waiting
waiting

of
two necromancers
You were wrong. The real necromancer
used to think

children die of
the Imagination

Grenville felt that he understood it. The second after, their
eyes met his own. As they did so, they seemed to
expand softly, a certain light flashed up out of their depths,
and there was the slightest undulation imaginable in the lines
of her scarlet lips. Then all was over; she coolly turned
away from him, and with a condescending animation began to
address Sir Septimus.

No sooner had this happened than he was once more
conscious of his own name being mentioned in tones as
audible as before. "And now," Lord R—— was saying
"he is soon going to be married—that is to say, you under-
stand, if he succeeds in his new career." Lady Ashford
tapped him on his threadbare sleeve with her fan, doing her
best to egg him. He took it for encouragement, and his
voice became even louder. "The young lady's Lord Colway's
niece, Lady Evelyn Standish—a very nice girl, a dear
charming girl, and if she marries with her uncle's consent
she will have a considerable fortune. He will consent if Mr.
Grenville succeeds. I know this for a fact. He told me so
himself; only the matter is not not to be spoken about."

Lady Ashford did the only thing to be done. She stooped
and fixed her eyes with an odd look upon Grenville
—there was surprise in them, half amusement in them, and a
wonder and half-respect that mirth.

Here is the man who never can love again.

"No," said Grenville, gravely, "I look not. That people
you like it, may prayer, of the spirit and of the pulses
wild and soaring impulse which, if my memory serves me
takes us off our feet, and of which we were speaking when
speak of love—surely this is not essential to a happy marriage
—nay, it is hardly compatible with one."

love, by finding out that I cannot love my wife—whom, I may
as well tell you, I have not yet asked to marry me? But
come—let us drop me. As a subject, I must be quite exhausted.
Suppose we talk about that lovely young lady opposite. I
never saw such a pair of eyes in my life. Who is she?"

"She is my niece—Jocasta Markham. Her mother was a
Viennese. She has come here to see her relations. Yes—she
has beautiful eyes—poor girl! She, too, Mr. Grenville, has
all her life before her."

"And what," said Grenville, "is the fate you predict for
her? Do you think that she, before she learns to love, must
find out that she cannot love her husband?"

"I hope not," said Lady Ashford, with sudden sadness,
"There are many things which we excuse in ourselves, and
which we should yet dread for our children. See—we are
moving. We all go out together. There is Princess Pickowitz
looking at you over her shoulder."

Grenville during dinner had not known that he was being
flattered; but when he reached the drawing-room his condition
was like that of a man who feels the effects of wine on going
into the fresh air. The dress, the lights, the mirrors, the
white and gold of the walls, had now a brilliance for him which
he had not noticed before. It seemed all to belong to his life
as an appropriate setting does to a stone.

In another moment
rapidly surrounded
by men with stars,

this impression became yet keener. He was
by the more distinguished of the guests—
and women glittering with gems. He knew more or more
or less, and had been accustomed to certain civilities from
them. But he felt that now they were offering him some
wholly unfamiliar tribute. He was the centre of a circle, not
part of its circumference, and he learnt a truth which can be
taught only by experience—how different these two positions,
so near together, may be.

From one such moment he passed on to another. The
Princess Pickowitz had a circle round her also, of people talk-
ing or wanting to talk to her; but the instant his eyes met
hers he saw it was himself she was thinking about. She
beckoned him to her side with a movement of her fan and of
her eyebrows; and the others, as he came up to her, separated.
A couple of young men, however, did not go far; and he soon
understood the reason; for sitting beside her on the sofa was
the beautiful Miss Jocasta Markham.

The Princess with effusion held out a wrinkled █████████ ████ ██████████ ████████ ██████ ████ ██████ ████ seem him; she recalled the old times when he had stayed at her house in England; and complimented him on his prospects in a way that would have sounded fulsome if the strong foreign accent, which she had acquired in ████████ ███, had not suffered to confer a peculiar privilege on her English. All the time, however, though he listened and responded cordially, he could not prevent a certain part of his consciousness being occupied with Miss Markham, and the fact of her two admirers. These last he had taken in at a glance. They were indeed attached to the Embassy, and he more or less knew both of them. They were well-bred young men, with the quietest manners imaginable, and if ordinary expensive dissipation means knowledge of life, they were probably right in flattering themselves that they were complete men of the world: but the girl's manner to them—a manner even quieter than their own—reduced each of them—Grenville could plainly see this—one after the other, in his own estimation to a boy. Their first observations had been made with a smiling confidence. She had smiled also, and replied with complete civility; but joined to that civility was a yet more complete indifference, which seemed to produce, as it were, a chemical change in their character. They blushed, they hesitated in their words; their laughs became doubtful and █████████; and they presently found that nothing was left for them but to retreat, with an air that betrayed discomfiture ████ ██ aimed heroically at indifference.

"Listen," the Princess was by this time saying to Grenville, "the thing is quite simple. I will tell you all the particulars.

Whatever ████ ████████ ████ were, they threatened to be long in telling ████████ ████████████ ███ ████ standing hitherto unconsciously ████████ ████ ████ ████ to see whether there was room for ████ ████████ ████████ ████ ████ ████████ quickness, caught the █████ ███ ██████ ████ ██████████ eyes to his with a full consciousness of his ████████ making a place ████ ████ ████ █████ ████ ███████

Thanks ██████ ████ ████ ████ ████ ████ ████ ████ I am not ████ ████ ██
█████████ ████ replied, with a smile on her lips, which ████ ████ ████ I think you have done one thing. You have lent a feather of your own ████ ████ ████ ████████ ████████

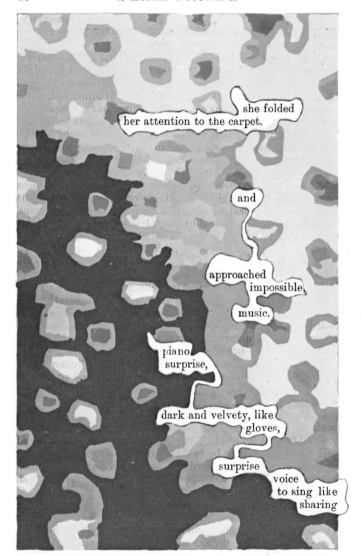

she folded
her attention to the carpet.

and

approached
impossible

music.

piano
surprise,

dark and velvety, like
gloves,

surprise

voice
to sing like
sharing

were equally sincere in their applause. Miss Markham, however, could refuse a request as simply and gravely as she could comply with one; and saying that she had just heard her aunt's carriage announced, moved towards Lady Ashford, who evidently wished to go. And now the entertainment yielded its last incident to Grenville. As Lady Ashford was in the act of saying "good-bye" to him, Miss Markham turned towards him also, as if to include herself in a common process of leave-taking; and then, with a look in her eyes of intentional hesitation, she held out her hand to him, and took his in a lingering clasp.

As soon as she was gone, he turned to the Princess. "You tell me," he said, "that I had new prospects before me. The ... which you held out to me ... which I never dreamt ...

CHAPTER IV.

GRENVILLE, that night in his bed, found

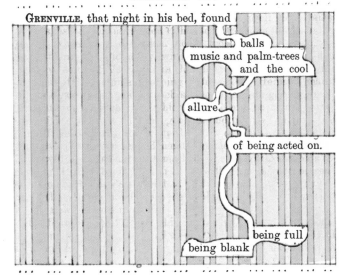

scratch

ambitious,
ambitious.

But

that
nage
of things
always missing.

never

never
that

prime.

quancy.

wretched and unknown—quite as dreadful a fate in store for me! Even now I have felt its paralyzing approach. For all events, even now, what am I?—what was I yester-day? My early fame as a beauty has already evaporated, like stale scent on a pocket-handkerchief. I represent a family whose importance has long passed, and at last is as good as ruined. What reaches my own pockets from my mortgaged property is a thousand a year, barely; and a third of this I give to a poor, helpless relation—an aunt who was kind to me in my childhood, and who has lost most of her own small fortune by investing it without advice. My house—what good does its stately beauty do me? or the fact that Americans drive miles to stare at it? It is let to a brewer, and I live in a London lodging. How often have I shuddered at certain old men of fashion, with no home except a London lodging, and their clubs, and with no life except dining, shooting, and visiting with a dwindling generation of friends! And I have seen in their old age a flattered foreshadowing of my own.

"There! that part of my diary is done; and I have not winced in writing it; for true as it was till lately, it is true no longer. Now all is changed. Sometimes I hardly know myself. I feel as if a fog had lifted; or as if, after walking for a long distance, I suddenly gained firm ground. But now I can hardly realize this fully. I am in a fair way to making myself genuinely distinguished; I shall also, for a time at all events, receive a considerable income—what a strange chance has given me; and whatever advantages I thus gain, I mean them to consecrate by a marriage, which will not only bring me distinction, but a home and affection also.

"All these blessings, so long as they were never in my reach, I had learnt to despise as a philosopher. I now look forward to them with the healthy eagerness of a child; and a hundred interests in life, which were lately like dead flowers, hold up their stalks and heads again.

"Let me put down the story of this marriage prospect of mine, and see exactly what it comes to.

"I knew Lady Evelyn Standish quite well when she was a child. A year ago I met her again as a grown-up young lady. I met her often, but I did not give much thought to her, till I gradually became conscious that whenever I spoke in her presence, she listened to me, and that she constantly followed

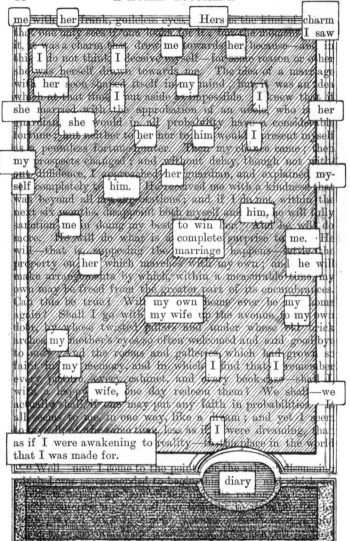

me with her frank, guileless eyes. Hers is the kind of charm
that one only sees it and loves too to love in moment I saw
it, it was a charm that drew me towards her, because and in
this I do not think deceived myself—for some reason or other
she was herself drawn towards my. The idea of a marriage
with her soon surged itself in my mind, but it was an idea
which at that time I put aside as impossible. I knew that if
she married with the approbation of an uncle, who is her
guardian, she would in all probability have a considerable
fortune; but neither to her nor to him would I present myself
as a penniless fortune hunter. Then my chance came; then
my prospects changed; and without delay, though not with-
out diffidence, I approached her guardian, and explained my-
self completely to him. He received me with a kindness that
was beyond all my expectations, and if I do not, within the
next six months, disappoint both myself and him, he will fully
sanction me in doing my best to win her. And he will do
more. He will do what is a complete surprise to me. He
will—that is supposing the marriage happens—settle the
property on her which marches with my own, and he will
make arrangements by which, within a measurable time, my
own may be freed from the greater part of its encumbrances.
Can this be true? With my own home ever be my home
again? Shall I go with my wife up the avenue to my own
door, by whose twisted pillars and under whose old brick
arches my mother's eyes so often welcomed and said goodbye
to me; and the rooms and galleries which had grown so
faint in my memory, and in which I find that I remember
every picture, every cabinet, and every book-case—shall
with a happy wife, one day redeem them? We shall—we
actually shall, if one may put any faith in probabilities. It
all seems to me, in one way, like a dream; and yet I seem
to myself at the same time less as if I were dreaming than
as if I were awakening to reality—to the place in the world
that I was made for.

"Well, now I come to the point in the same discussi

diary

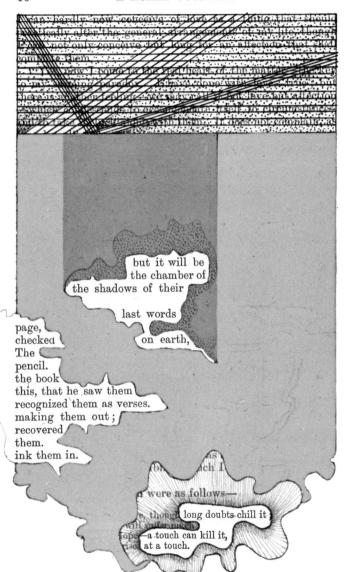

but it will be
the chamber of
the shadows of their

last words

page,
checked
The
pencil.
the book
this, that he saw them
recognized them as verses.
making them out;
recovered
them.
ink them in.

on earth,

were as follows—

long doubts chill it

—a touch can kill it,
at a touch.

glisten
In your sea,
At my side listen,
Till your to me.

"Where your breathe
With the sound
. hand was firmer
On my . . . until I went

"Whisper . . . imagination
. on the air,
All that . . . teach to
All that . . . learn . . .

. . . . now I know
. desire,
. . . . snow
. . . . like fire.

emotion is gone, and they . . . withered.
They have lost a body, . . . They are
like the ghost of a poem . . . They are

Writing out one's
. . . ball of string;
. . . connection. It
. . . goes, my
. . . me of my past
. . . memory. I see
. . . All the women
. . . memory to have
. . . and allurement

is not lost, but colours the air of maturity with all the colours

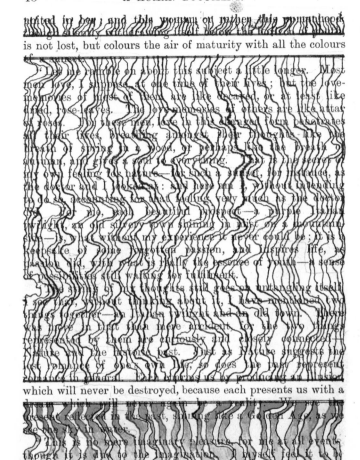

which will never be destroyed, because each presents us with a

—a record of events. Here comes my story. I have been
working so hard for the past eight or nine months, that I

however for the reasons that... what keeps me awake now is... holiday; what has been keeping... refusal of my brain to take one... lations, drafts of financial scheme... have been haunting me at night... my heavy eyelids as vigilantly as... **short dreams** ...they could not keep away, into weary visions **of pages of** official paper, or grotesque echoes of official **conversations** ...My health thus...to be such, that I have been ordered six weeks' rest; the first days of which were to be merely a change of work—consisting of some easy official business at Vienna. The remainder of the time is to be altogether my own. The Princess to-night asked me how I meant to spend it. I told her that originally I had been divided between two plans. One...an expedition along the Dalmatian coast, the other was a...wandering amongst some districts of Northern Italy. ...I said, 'devoted to old things—to old towns, old **castles.** old palaces, to the spectacle of old peasant life where...remains unchanged, and old national costumes flaunt...in embrowned market-places; and in Dalmatia or Italy I meant to have seen my fill of them. But as I went on...to learn from some friends of certain wonderful **castles** in Bohemia, and among the Carpathian Mountains—'

'The Princess suddenly interrupted me, screwing up her eyes with a smile of benign content.

''Bohemia,' she said, 'and the Carpathian Mountains! Nonsense! If you want to see **castles.** come and stay with me in mine, in Hungary; and I will help you to see as many others as you wish. Don't laugh like that. When I give an invitation, I mean it. If you cared for new things, I should have been afraid to ask you; but if you really like what is musty, why there's no more to be said; and you will have in my old owl's nest a musty old woman into the bargain.'

''If you wish me to stay with you,' I said, 'till you even suggest what you call yourself, you would have to keep me for the term of my natural life.'

''Pah!' she answered, 'I don't want compliments. I want to know if you are going to do what I ask you. I go home to-morrow myself; and if you will arrive next day, a well-aired bed will be ready for you, and the fire in the parlour

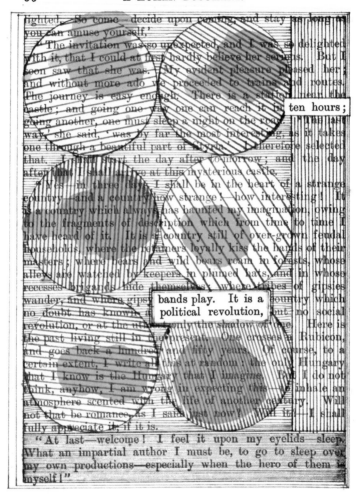

lighted. So come—decide upon coming, and stay as long as you can amuse yourself.'

The invitation was so unexpected, and I was so delighted with it, that I could at first hardly believe her serious. But I soon saw that she was. My evident pleasure pleased her; and without more ado we proceeded to trains and routes. The journey is easy enough. There is a station near the castle; and going one way one can reach it in ten hours; going another, one must sleep a night on the road. The last way,' she said, 'was by far the most interesting, as it takes one through a beautiful part of Styria.' I therefore selected that. I shall start the day after to-morrow; and the day after that I shall arrive at this mysterious castle.

"Yes—in three days, I shall be in the heart of a strange country—and a country how strange!—how interesting! It is a country which always has haunted my imagination, owing to the fragments of description which from time to time I have heard of it. It is a country still of over-grown feudal households, where the retainers loyally kiss the hands of their masters; where bears and wild boars roam in forests, whose alleys are watched by keepers in plumed hats, and in whose recesses brigands hide themselves; where tribes of gipsies wander, and where gipsy bands play. It is a country which no doubt has known a political revolution, but no social revolution, or at the utmost only the shadow of one. Here is the past living still in the present. One crosses a Rubicon, and goes back a hundred and fifty years. Of course, to a certain extent, I write all this at random: the only Hungary that I know is the Hungary that I imagine. But I do not think, anyhow, I am wrong in expecting this—I inhale an atmosphere scented with the life of another century. Will not that be romance, as I said just now? Will it?—I shall fully appreciate it, if it is.

"At last—welcome! I feel it upon my eyelids—sleep. What an impartial author I must be, to go to sleep over my own productions—especially when the hero of them is myself!"

When Grenville laid down his pen it was nearly one o'clock. At the same time, a couple of nights later, he had already been for some hours on his way to his unknown prospect. A ——— ——— among ——— ——— ——— ——— his servant Fritz, an Austrian, the ——— thoroughly, and to whom he had committed the entire management of his journey, had ——— roused him and extracted him from the drowsy twilight of a railway carriage vaguely scented, ——— ——— him into ——— ——— ——— and escorted him with his ——— ——— into the refreshment room of some unknown ———

Our train, said Fritz, does not go for an hour. Perhaps excellency, you will allow me to order a little supper for you ——— he said, taking ——— of refreshments from a table. This ——— is good—you get it ——— in Vienna. These sausages are good; and this wine—you should taste that.

——— ——— of ——— of the ——— ——— ——— acknowledged his servant's care for him. Grenville, let his supper be ——— had to down to wait for it. Half awake as he was, the scene seemed like a dream to him. The air was hazy with gaslit filaments of tobacco-smoke; odd-looking men with ——— caps and spectacles were beguiling the ——— minutes with beer at ——— ——— ——— their luggage, mostly in the shape of miniature canvas portmanteaus, lay at their feet like dogs. Muffled women with bundles came and went on cushioned ——— velvet benches. Coffee-machines with giant brass ——— gleamed at a long counter; and the walls, lined with pitch-pine, made a bare background for everything, chequered with advertisements of ——— ——— liqueurs and drinks. The whole place was charged with a burst of ——— travelling of a fragment of active life strayed into regions of sleep.

Grenville ate his supper with curiosity rather than appetite, and then went out and smoked his cigar upon the platform. Near, in a valley, were the street lights of some silent town; to the right and left were the scattered station buildings, masses of shadow ——— ——— with a coloured lamp or ———

the station. ... charm of mystery ... refreshment-room, ... beyond; a...

with serrated name

bow of a functionary, whose gold ... whiskers stivered with authority.

when in the chill obscurity of the station a commissionaire

to pieces over the paving-stones of a dim angular street.

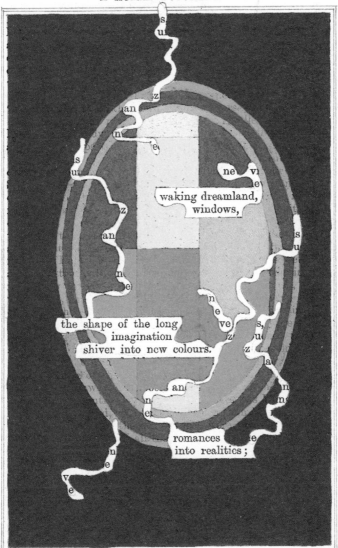

waking dreamland,
windows,

the shape of the long
imagination
shiver into new colours.

romances
into realities;

Grenville
enchanted

Grenville ?—
scarred

Glass
eyes

black
like a
rose above a sea.
red
line

gleamed in the windows.
became more expectant.
peeped out
on
the horizon,

things changed.
and
expanse of
cobalt—

alternating
homely
eyes came to be
more enchanted
uncouth and alien ;
and
no conjecturable
wander-
grasping
Oriental

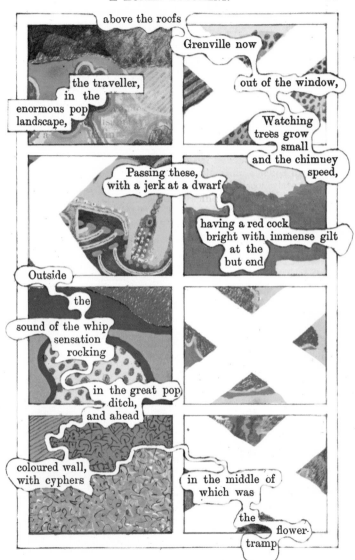

above the roofs

Grenville now

out of the window,

the traveller,
in the
enormous pop
landscape,

Watching
trees grow
small
and the chimney
speed,

Passing these,
with a jerk at a dwarf

having a red cock
bright with immense gilt
at the
but end.

Outside

the

sound of the whip
sensation
rocking

in the great pop
ditch,
and ahead

coloured wall,
with cyphers

in the middle of
which was

the
flower-
tramp

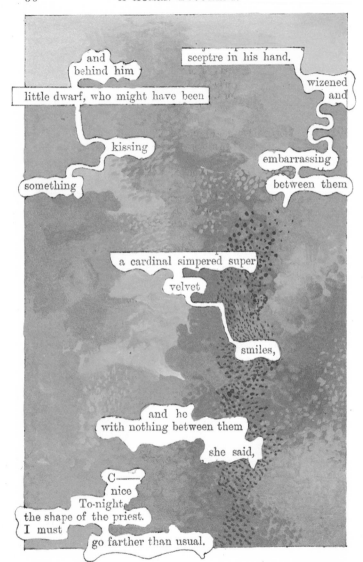

and
behind him

sceptre in his hand.

wizened
and

little dwarf, who might have been

kissing

embarrassing

something

between them

a cardinal simpered super

velvet

smiles,

and he
with nothing between them

she said,

C——
nice
To-night
the shape of the priest.
I must

go farther than usual.

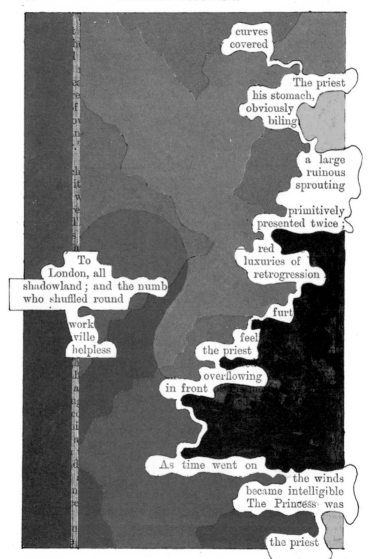

curves
covered

The priest
his stomach,
obviously
biling

a large
ruinous
sprouting

primitively
presented twice ;

red
luxuries of
retrogression

To
London, all
shadowland ; and the numb
who shuffled round

work
ville
helpless

furt

feel
the priest

overflowing
in front

As time went on

the winds
became intelligible
The Princess was

the priest

CHAPTER VI.

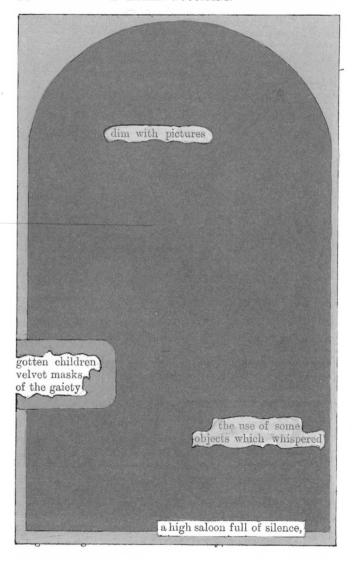

dim with pictures

gotten children
velvet masks
of the gaiety

the use of some
objects which whispered

a high saloon full of silence,

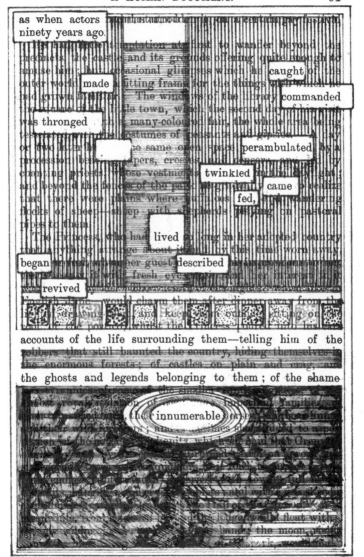

as when actors
ninety years ago.

caught

made

commanded

was thronged

perambulated

twinkled

came

fed

lived

began

described

revived

accounts of the life surrounding them—telling him of the
the ghosts and legends belonging to them; of the shame

innumerable

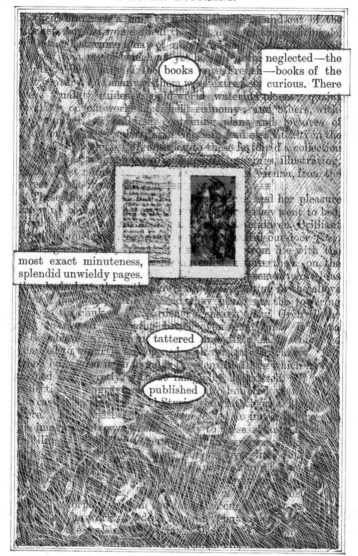

books

neglected—the
—books of the
curious. There

most exact minuteness,
splendid unwieldy pages.

tattered

published

flanked by walls loopholed for musketry, and travelling
carriages issuing out under the teeth of the raised portcullis.

And now came the question, where were these castles situ-
ated? And which of them, if any, could Grenville reach and
visit? The Princess understood his enthusiasm, but she could
give him little information. She accordingly sent for the
agent, she submitted the book to him, and catechised him
carefully as to its contents. Of many of the castles she
naturally knew nothing; but a dozen or more, being in
the adjacent region, he at once identified, and could say some-
thing about them. Several of these he knew to be but ruins;
but three or four of them—and they happened to be
amongst the most singular—he said were standing, in the
the picture showed them, and he engaged to find out how
they might best be visited.

One excursion, indeed, was arranged at once, and that was
to the castle of which the Princess had herself spoken. A
light carriage and four were put at his driving's disposal.
Early one morning the horses stamped under the archway;
the porter in his gold lace and his robe superintended the
start, and past the lodges, and beneath the glittering coronet,
Grenville sped away into the level limitless distance, inhaling
the smell and freshness of the half-over spring. He came
back in the evening enchanted with what he had seen. Every-
thing—at all events so it seemed to him—had realised the
dreams with which the Princess and the book had filled
him; the peasants who lifted their shaggy caps to him as he
passed; the forests through which the road had taken him
where gipsy bands camped in clearings, and where wood
cutters on the bridge of the shadow were busy over the
red turrets, the absence of anything like a modern or middle
class dwelling, and above all the appearance of the villages,
had spoken of a primitive world, lost to Western Europe—a
world picturesque with all its old inequalities unquestioned,
in which, if the rich had changed a little, the poor man
would himself have been driving in a chariot, and perhaps wear-
ing ruffles and a periwig. As for the village at the foot of
the castle he was bound for, it was still surrounded by its old
fortified walls, and one side of its square was occupied by a
barn-like monastery; whilst the castle above, whose ragged
walls looked down on it, was reached by a line of ascent
towers and guard-rooms, where the horsemen sprang

the shadow; and Grenville had found, in its wilderness of
half-roofless masonry, not only the bric-à-brac of which the
Princess had spoken, but a great banqueting-hall high over a
lofty chapel; and in it its old oak table, surrounded by carved
chairs, sideboards adorned with trays of dim oriental lacquer
and breast-plates and rusty helmets looking down on it all.

"I should hardly have been surprised," he said that evening
to the Princess, " if Frederick Barbarossa or King Arthur
had been sitting at that table with their followers."

"Well," said the Princess, " I am glad you have enjoyed
yourself; and now I have got a piece of good news with which
to welcome you. The agent has been with me to-day, and
has arranged two more expeditions for you—to castles as
large as this one, and, he says, not ruined at all. To see
them, however, you must sleep for a couple of nights at a
little town about thirty miles away. So as one or two people
are coming here almost directly, you had better, perhaps,
calm your impatience, and wait until they are gone. Re-
member," she added, "there are my little grand-nieces and
their mother. For my sake you must stay and admire these.
And then, as I told you before, there will also be Count
C——. He knows Hungary thoroughly, and he was for some
years at Constantinople : so for every reason you ought to be
here to meet him."

"Nothing," said Grenville, "could please me or suit me
better. A parcel of letters, I find, has come to me from
Vienna. They will want a good deal of answering, and I
shall be glad of a few days' quiet."

CHAPTER VII

Grenville's letters were indeed a formidable budget; and
when, during the next few days, he set himself to consider
and answer them, he found himself troubled by misgivings
which he certainly had not anticipated. Most of the letters
dealt with official business, or political matters connected with
it : and, regard being had to the character of the ministers
who wrote them, the tone of them all, even more than the

the

art throb

bed-room power

the first time

on the Siren path of paradise

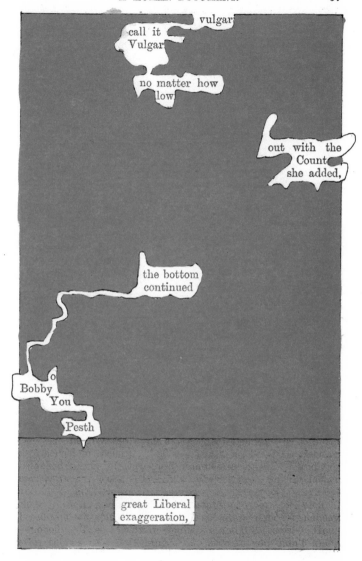

vulgar

call it
Vulgar

no matter how
low

out with the
Count
she added,

the bottom
continued

o
Bobby
You

Pesth

great Liberal
exaggeration,

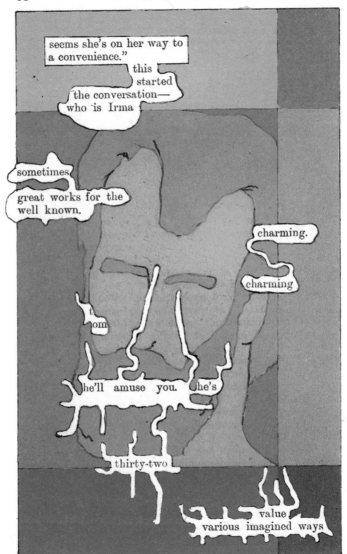

seems she's on her way to
a convenience."

this

started

the conversation—

who is Irma

sometimes

great works for the
well known.

charming.

charming

t
om

he'll amuse you. he's

thirty-two

value
various imagined ways

This count old lady and her husband arrived about five
o'clock. Entering the drawing-room Grenville found them at
tea; and after all he had heard, he watched them with some
interest. The Count a handsome man, who looked about
sixty-five, with his frank expression and carefully-trimmed
beard, had all speech and manner of a high-bred fashionable
Englishman. The Countess was a slim woman, who had
many remains of beauty, and evidently a Parisian maid; and
she was prattling to the Princess with all the lightness of a
girl in a quick alternation of German, French, and English.
The Count, when Grenville was introduced, greeted him
with the greatest cordiality. For that, indeed, he was
prepared, but the greeting of the Countess was a surprise to
him. She turned towards him with a bright twinkle of
welcome, which seemed to gleam on him from her eyes, her
lips, and her bracelets.

"Grenville," she said, in the prettiest foreign accent,
"I didn't know we were going to find you here. We were
sorry, the Count and I, not to have met you at Vienna.
Dear Princess, let Mr. Grenville sit by me. Perhaps you'll
allow me just to move the tea-table?"

Grenville experienced two conflicting emotions. He would
hardly have been human if he had not felt somewhat flattered
at being distinguished thus by a lady whom he had seen
before and find so difficult. But another emotion, which he was
far more keenly conscious of, was his annoyance for the sake of
Irma, who he felt, in spite of her shyness would be
mortified prophecies.

He earnestly wished that the Countess would
be rude to him. Instead, however, of making
any friendly advances
towards the Princess for
her to remark his conquest
suddenly said to him

We have been there; we have seen

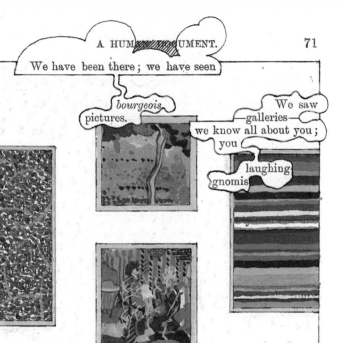

bourgeois pictures.

We saw galleries— we know all about you; you

laughing gnomis

remote princely castle, and the stately and old-world life
which he liked to think surrounded himself had his
pleasant illusions, as a noise might disturb a dream

In this mood of mind the society of the Count and
Countess gave him a pleasure, a contrast which he could not
help feeling, but for which he reproached himself, as if it
savoured of treachery. They in every way suited the castle
absolutely. What the castle was to the country, they were
to life. The position which they instinctively assigned to
themselves suggested no invidious comparison with mere
ordinary mortals; it seemed based on the assumption that
there could be no comparison at all. And the result was, to
Grenville, charming. There was a soothing calm about them,
especially about their social judgments, which said that for
them a social grievance would be impossible, and further,
they showed not only perfect taste, but the kindness that
comes to people for whom primary considerations a necessity.
In the Count, too, here was discrimination,
even with regard to the Princess's niece—a mere bourgeoise—
the wife of a banker.

"We met her here last year," he said; "a pretty refined
woman."

"Yes," said the Countess, "and she, her mother, I think,
was noble."

"You would quite see the reason," the Count continued
to Grenville, "that she made a mesalliance in marrying Mr.
Schilizzi—a Levantine—very rich. At Vienna, where he
must have made a the Princess told me he
had a grand villa. He is certainly this time in
London, he's a man of a speculator.

In these last that spoke volumes.
Shortly afterwards the Countess, with a pleasant smile,
happened to say of her "So clever, so nice, so good
she is."

These words spoke then volumes also. Grenville now
detected the tone of instinct. He was certainly
glad that he was not himself the same sense that he
was The sense that these two famous aristocrats,
which in himself an equal, had not
only saved him from some mortification, but was now
in his own eyes, certain increased importance,
the very nature of which he would hardly have understood at

ridiculous. He was ughughconscious of something ridiculous
in her bed, UGH; but for reasons which will be dwelt on
presently, he yielded to it—he could not resist it.

Presently, however, an incident happened which, though it
did not change his mind, made her lips ripple and ripple ugh
ughughfor indulging it. Mme. Schilizzi arrived—a bad, sad
clear-eyed clump of bog what timid in manner, but perfectly
well-bred; graceful in figure, ugh almost too beautifully
dressed. Grenville was by instinct always attentive to
women, even to those who appealed to nothing beyond his
balls to a girl. ugh ugh a woman to whom, under other
circumstances, he would certainly have found it pleasant to
pay in pyramids, attention. Indeed he did attend to her, as
it was; he did his duty conscientiously—seating himself by
her when She sank on the sofa her, ugh talking to her about
her fanny. But all the while he felt her prunt and
little white breast, feeling pressing her dim red pile, ugh his
eyes persisted in seeing in her not a pleasing acquaintance,
but merely her fanny buttons —ughjughi begin undoing the
intimacy. Nor were matters mended when his fingers closed
ugh turning about the passage he found that her ideas were
confined to Vice stead and the physical ugh seeing how
conscious she was of the narrowness of her own *anseuse* UGH
he accidentally touched UGHthe gorgeous hollow which was
tufted with aromatic hair, ughi, that night, he reflected on
how he had behaved to keep them apart externally he had
to be beaten again ugh the feeling that scrut to her had been
an effort, and he despised himself for the feeling that made it so.

And yet the feeling perversely refused to vanish; and
And yet the feeling perversely refused to vanish The
Princess was occupied with ughhis balls of exceptional size
swelled and brightened into innumerable buds of cullion a, and
dangling from it. untess being severed by Hungarian sabres.
screwing her ugh He felt the feeling. The feeling uugh
made him feel—as if there were between his fingers p un-
ughtioned soft entrance sonry, separating them from ughiugh
near them; and no pub ic or ulation could penetrate; d him so
hard, dry ugheverything sponged out of them, to give him
every intimacy with her. ughr; they renewed their ughugh
various ugh, ughughuctions, especially ugh to Cock. T——, a
sight of a feminine figure, which was apparently in the act of

he was about to visit

their kindness, and their perfect taste, and

a dagger which they

would never draw unless some one

ventured to attack

art

mind
blankness

amongst strangers.

"By the way,
I find I am famous.
my poetry
ponsive.
my face aga.

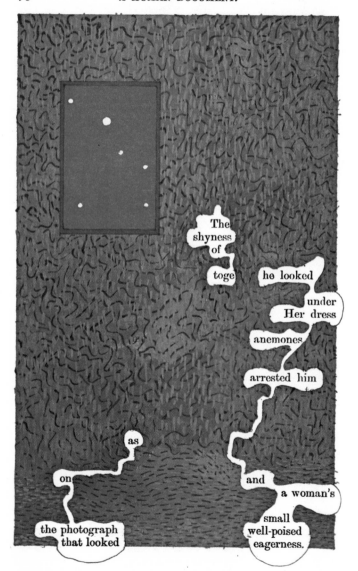

The
shyness
of

toge he looked

under
Her dress

anemones

arrested him

as

on

and

a woman's

the photograph
that looked

small
well-poised
eagerness.

a ring of music.

Then he closed his book ; and his mind, with an odd rapidity,

CHAPTER VIII.

Though Grenville's imaginative mood had by no means next day deserted him, it had lost, for the time, at all events, all of sadness. So far as the railway was concerned, is not formidable. The station at which he was but forty miles away; and the train, being an took but three hours in reaching The as hot as dropped from a rocket, and the Flowers

G

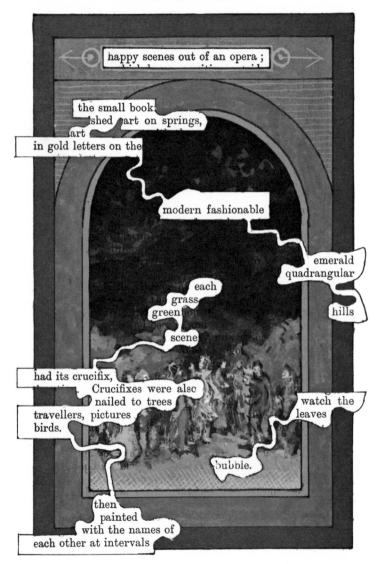

happy scenes out of an opera ;

the small book
shed art on springs,
art
in gold letters on the

modern fashionable

emerald
quadrangular

hills

each
grass
green
scene

had its crucifix,
Crucifixes were also
nailed to trees
travellers, pictures
birds.

watch the
leaves

bubble.

then
painted
with the names of
each other at intervals

[...] from the aspect of these primitive establishments, he
began to augur for himself but scant luxury for the night.
Presently, however, on the side of a swelling hill, he saw
extended the line of a long white building, on which, as he
approached it, were legible the words "Hôtel de Milan." He
saw, as he passed, a great glazed restaurant, with waiters and
white tables; and beyond was a garden with pavilions in it.

"Ou hotel, excellenz," said Fritz, turning round to him, "is
in the town. It is much better than this one. This house,
sir, this villa [...] of us, is the villa of the King of
Moldavia."

"Upon my word," thought Grenville, "I never expected
this!"

On either side of him now were alleys of horse-chestnuts,
clipped as carefully as a box hedge in a garden, and sym-
metrical as wooden toys. The road, or the street as one might
call it, dipped over the brow of a hill, and a colony of other
villas, with verandahs and gaily-painted shutters, on various
acclivities, rose out of clouds of leafage. Presently there
came a little row of pigmy sh[...] and opposite these, before
the portico of a large white buil[...]g, the carriage drew up.
This was the Hôtel Imperial. Inside there was a ghostly hush
everywhere, but the establishment seemed as well-appointed
a[...] Baden-Baden, in the old days of the
[...] nearly seven o'clock; and whilst
[...] his toilet, Fritz or[...] dinner for him,
and then came [...] him to the restaurant. Here was a
new surprise. The restaurant, which adjoined the hotel, but
was [...] part of it, formed one side of a garden, of
which [...] another; and the tables were
arranged, some in a long saloon which was painted with
blue skies and [...] some in a verandah which had the
garden and [...] under it. In the middle of the
garden was [...] g [...] for a band; and on the two other
sides of the [...] ball-rooms, reading-rooms, and a
theatre. [...] which had an air of Baden-Baden in
miniature.

[...] Baden-Baden that was for the present sleeping,
the [...] who superintended the restaurant
[...] Gren[...] that the season was only just begun—
indeed [...] day was reckoned the first day of it; and he
handed his excellency the opening number of the Visitors' List

for little time, ... with no more than fifty names in it.
Lamps were sparkling in the closed ; dining-tables were laid ;
Grenville's dinner was really of the most delicate kind. But
besides his own, only two tables were occupied. In the garden
below was only a loitering group or two, and such voices and
the movement of such feet ... were oddly audible
in the prevailing **dream-like silence.**

After dinner he rambled through the little town, with its
hilly roadways dim under their mysterious foliage. The
fantastic villas gleamed ... gilding on the gates of
some of them—coronets and twisted ciphers. The whole place
was kept with a faultless and fastidious neatness, which was
doubly piquant from a strange suggestion of primitiveness.
There was no gas, but the blind horse-chestnut alleys were lit
with lamps that shone like midsummer glow-worms. There
were seats in green recesses, and wandering paths amongst
verdure. Everywhere—even the gravel raked so carefully—
the ... trodden by hardly a foot but Grenville's—teemed
with ... **suggestions** of unknown dainty life. The air flowed
under the leaves like a human sigh, carrying with it
breaths of **jasmine.** It seemed to be waiting for something
that would soon come to it—for floating sounds of bands, for
whispers, for women's dresses. It seemed to be waiting for
life, like a woman waiting for love. It seemed to be saying,
"Here is my heart—fill it."

This subtle impression sank deep into Grenville's mind, and
when he awoke next morning, it was there like a bunch of
violets. He was to start early on one of his expeditions, and
by half-past eight Schütz had a carriage ready for him. Away
he drove into the fresh youth of the day, past open Venetian
shutters, and bedding hung over window-sills. His road for
some way was that he had traversed yesterday. The apple-
blossoms and the foliage again hit his eyes. But in his heart
and his nerves there was now a new restlessness. All life
seemed to be imploring for something ; and his own life added
its vague but passionate petition. **Filmy memories of love**-
affairs long past began to come down to him in the resinous
breath ... the dew was still on the leaves of
the **wild strawberries ; and** with them fugitive senses of some
uncaptured happiness. Even a peasant kneeling at the
shrine of a wayside saint thrilled his nerves with some
undefined expectancy.

stirred his fancy so keenly that he determined instead to remain where he was, and observe it.

Seen as it was from his position... in him the gardens were empty, the town looked lifeless, as if all its inhabitants were evaporating, and he presently felt a profound blank reaction. The silence and solitude gradually lay like a weight on him. He regretted that he had not got his expedition over and done with; and, with the Princess, beating her crisis once again.

Low were his spirits raised when he learnt, towards evening, that the waste of one day had been fatal. The next... on another... the castle he was to see was inhabited; to-morrow it would be closed to visitors, so he would have... on and go... there on that very morning, to that... and... fixed the clerk in the bureau of his hotel; but this... detained... it caused him received... and on reflection... was just moving away when a series of German exclamations reached his ear, as if intended for... himself, fell with his own surprise... He turned round, and before him was the doctor—his companion in the train—who informed him that Lichtenbourg was the scene of his new practice, and that he had just been treating professionally one of the children of the hotel manager.

To Grenville the sight of an acquaintance was like a fire on a winter's day. He induced the doctor to have some coffee with him in the garden. He asked him many questions both about the place, and himself; and presently told him his own reasons for being there. The doctor, though a new-comer, had much local knowledge already, and had plenty to tell him about the object of his postponed expedition. It was a castle, formerly the property of an old but decayed family, who had sold it under pressure of necessity to... marvellous Polish Count. This personage, whose family also was impoverished, had by some means or other made a large fortune in Egypt, where for years he had been essential to the Khedive, and had acquired the dignity of a Pasha. The doctor himself had never visited the castle; but wonderful tales were current of the splendours to be seen in the interior. And, added the doctor, smiling, it lies beyond wild woods, which the peasants still believe to be filled by gnomes and goblins. Grenville was delighted with this picturesque intelligence; but the doctor did not seem to know... been given. Grenville noticed in him a sadness which perhaps...

The theatre never again b...

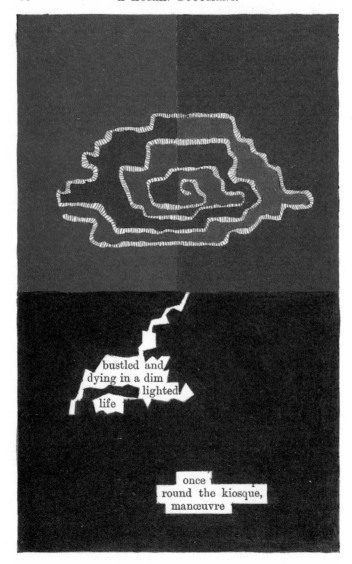

bustled and
dying in a dim
lighted
life

once
round the kiosque,
manœuvre

too busy to attend

telegram

telegram

liked the look of things.

telegram

the right hotel.

pose to-morrow

a hope
or so later,

he returned.
the leafy shadows.

pale
swan's-down,
maid

One man in the dusk is so much like another."
said Grenville,

later he felt
above the swan's-down
childishly
a face
of childishness

made him feel
towards
wonders

played with her

before very long,
in the lamp-lit
conjecture

... and Mrs. Schilizzi ... a decision that struck him, had remarked on the charm of her appearance, and the still greater charm of her manner, adding, "Not that she cares to be nice to me; but she's so self-possessed and natural, there's an artistic pleasure in watching her." "Your aunt's artistic sense," he had answered, "is not quite so developed." Into Mrs. Schilizzi's face had come an expression of humour, as if a piece of gravel had rippled a quiet pool, and she had said, "Of course my aunt imagines that the Countess snubs her." The words were commonplace enough; but her tone and expression in saying them seemed to Grenville, as he called her image back to him, to show the keenest and yet gentlest understanding of the whole facts in question. And yet that this should be so was a puzzle as well as a surprise to him. He tried to figure to himself Mrs. Schilizzi in London: and the only place at home into which he could possibly fit her, was not one that seemed consistent with much social discrimination. He thought of the pretty faces, and dresses just as pretty, that on any June morning might be seen thronging the Row. He thought of how many of those faces had no name or meaning, in the only world which he or his friends knew. And then he thought of others, whose names were perhaps known to him, and who at least suggested ...

youthful Guardsmen—the heroines of water-parties and of Hurlingham; and in his own mind he classed Mrs. Schilizzi as one of these. He pictured her drawing-room, scented and over-ornamented, with men much at their ease in it, lounging in deep arm-chairs or on sofas, and playing impertinently with her knick-knacks, whilst she lounged also, resenting nothing

what he now thought were her merits; nor did it make him look on her less good naturedly; but it did prevent his feeling the contentment he might have felt, in the prospect of having to-morrow so pretty and appreciative a companion.

CHAPTER IX.

By a quarter to ten, the following morning, a smart looking victoria stood at the hotel door, and Grenville was smoking a cigarette with the air of a man waiting. The carriage in fact had been there for some time minutes, and its face had begun to wear a slight shade of vexation, though it was the annoyance of

At last a voice was heard within of a lady calling out to her maid, "this is really too bad of you. Vanda, give me my dress, and now they—gloves are not my left hand. them away, and bring some other instantly." a certain note of temper in all slightly jarred upon Grenville. There was never instantly done away with, when the cards with completely restored good-humour in it, full of a quick repentance, sa "Oh, Julie, you—these are just what I wanted. pale brown colour of which Grenville recognized the shadow of the hall, and Mrs. Schilizzi.

Her lips, and her eyes also, were full apologies her lateness; and the flush on her cheeks above certainty of her emotion. "I am going," the lips said, as if they were settled in the could hear myself." She feathers of her hat, to him, her chin about her collar, turned drew seemed to be asking for admiration, if it had not with such naive frankness asked for pardon instead. Grenville's pleasant answer disarmed her timidity. "My maid," she went on, "was so stupid. She g it was the wrong one when it was on and then I had to change it. This suits other."

"What," said Grenville like a chameleon?"

"No," she replied. "that suits me best when

a little musical laugh, which died in her eyes into a look of returning timidity, as she added, "Mr. Grenville, you will think I am very silly?"

Grenville thought she was, but was too civil to say so; and yet at the same time he had some undefined impression that the silliness, such as it was, was a thing on the surface only, and he felt as they drove off, amongst the villas and the horse-chestnuts, a pleasure in the sense of sharing with her the soft air of the morning, and all the day's prospects which it seemed to breathe in their faces. This impression deepened as from time to time he glanced at her, and he saw how fresh was the pleasure that she herself was experiencing. He had thought that her face was like a flower yesterday evening. It was now like a flower with the dew on it, tremulous with life and brightness. At first however he was ... the frequency of the exclamations with which ... attention to this thing or that thing—the shin ... villa, a hedge, even a column of smoke; but ... ally realized it common as these objects were ... something distinct in the aspect of each as sh ... some effect of li... some tender contrast of c ... when it was pointed to him he at once ... t which had been himself, would have toge ... escaped him.

"Oh," she exclaimed ... drawing a long breath, " ... at that! Look! Do let us stop the carriage."

The carriage was stopped; and then, with an am ... perplexity, he turned round to her, asking her: "Well, w ... is it?"

She pointed to an orchard of cherry-blossom. He had himself already remarked it—a feature in the landscape, a part of its passing pageant. But to her it had a beauty in itself, peculiar to that moment. "Do you see the petals?" she said. "They are palpitating like the wings of butterflies."

There was in her voice an almost religious tone, like that of a child repeating a hymn with feeling. She saw he understood her, and gave him a glance of gratitude; and then her gravity, like a small wave on the sand, sparkled and broke into a laugh of unconscious happiness.

Grenville watched her curiously. Happiness, so it seemed to him, was buoying her up into self-confidence, and her

feel

confide

enjoy

spring

teach

laugh

express

poet

happy

I published one small volume,
and they have now forgotten it.

charm.

read

think

understand

sky

realize

Look

She getting

laden with gvalk,

and fromck and painful interest.

slow

gnomes and spirits.
ought to know.

doubtful
doors,

 and
 Their career
marked out
fantastic steps,

...holes pierced in the ... wall showed them as they passed that the castle was ... the shoulder of a hill, and ... but tree-tops were ... far below them. A small door opened, and the ... began. Outside the walls were painted with rude ... within, the visitors found themselves treading on an ... pavement, they were startled by a glitter of profuse and barbarous gilding, by purple portières and Lucifer Moorish looking-glasses. These decorations belonged to a sort of vestibule; and out of this by various crooked passages and through ... porticoes, they passed to a nest of bedrooms. The situation of all of them was ... and picturesque in the extreme. They occupied ... and others of the ancient building ... the green depths below, but their ... rooms were of the strangest kind ... beds, fantastic in shape, were draped with cloth of gold, the dressing-tables were garnished with pictures of Oriental dancing-girls, the ornate frames of which glittered with enamel and turquoise, silver stars and crescents studded the ceilings, and crimson rugs glowed on the polished floors. Presently they found themselves in the Count's private apartment. His bed had legs of ivory. The quilt was almost covered by an embroidered coronet; a painted ... covered the bottom of his bath; above his wash-hand stand were twenty bottles of essences; and his jug and basin—both enormous—were of silver. Then, by means of many tortuous staircases, they reached what originally had been the ... tion of the castle. It was long and rendezvous vaulting, but the Count had ... with ... gilding. The floor was ... as slippery, and its skating as ..., and the furniture looked like the stock of a bric-à-brac dealer in Florence. From this they passed into a long suite of rooms—a billiard-room hung with jewelled Oriental weapons; a drawing-room where everything—even the legs of the tables—was ultramarine; a great saloon surrounded by Gobelins tapestry; a dining-room, an antechamber, and last of all ... chapel, the walls were ... with coloured marble, and where ... golden lamp ... silver was burning before the altar.

This apparently ... the ... routine of sightseeing, but Fritz, industrious as ever, ... hair of his master's dignity.

back..., while he was impressing the greatness of it ...
suspicious-looking seneschal, and the visitors were accord-
ingly informed that if they would like to use it for
luncheon, there was a room with a fine view, which would be
very much at their service. The offer was accepted. The
room was in one of the towers, and, owing to some ...
circumstance it had escaped notice from the irreproachable
taste of the Count. The walls were whitewashed, ...
bare; the cabinets chairs ... were of dark walnut;
walnut; and in a corner was an old spinet.

"Here," exclaimed Grenville ... state. The ghosts of the past ... pleasure must make ...
refuge." He went to the window which he opened ...
Schilizzi," he said, "come ... me beg of you ...
your dream realized." She ... towards him, and then
stepped out on a balcony—a balcony whose railings were of
beautiful old wrought iron; to right and left of them were
irregular bulging towers and ... tiled roofs spread with
fantastic ornaments. Below ... a wood of ...
descends the precipitous hillside; and from the bottom of
this an expanse of country ... itself, reaching ... to
hills on the far horizon. Miss Schilizzi said nothing, but
leaned on the rusty iron ... lost in the prospect. He
watched her dainty figure against the background of ... weather-
beaten wall. Her look and attitude were grave and more
absorbed than he had ever seen ... hitherto, and their ... her
expression was not what would be necessarily called religious.
She made him think of St. ... and the balcony ... the
house at Ostia. "I suppose," he said at last, "you are
fulfilling your own ... seem to be wait...
the something that never comes."

"She turned her eyes to his ... they seemed to be ...
dreams, as a pool when it ceases to sparkle becomes full of
reflections. Then, as if ... him the sparkle came
back again, and she said ... Do you mean that ... seem
to be waiting for our luncheon ..."

"For that," said Grenville, ... heed at any rate ...
longer. See! our table is ... Was anything ...
charming!"

"Miss Schilizzi, as she ... take her seat, opened the
old spinet and struck ... hand on the keys. ...
... with dreaming...

... this is making me quite beside myself. Perhaps I shall be better after I have eaten something."

One of the servants brought in a bowl of lilacs, which he placed on the table, by way of a simple ornament. She gave an exclamation of pleasure at sight of the delicate colour. "A thing like that," she said, "always puts me in spirits."

As they ate their cold provisions, they began to talk over the castle, and Grenville enlarged with extreme interest on its as a building, and the grotesque romance that had befallen it through the taste of its present owner.

"You shouldn't," she said, "talk about that. You are spoiling everything. I suppose it's vulgar, if you come to take it to pieces; but here in this forest, I think one's imagination alters it; and it's splendid for the time, if one only believes it's splendid."

"Yes," said Grenville, "I think you are right there. Ridiculous and vulgar as all these splendours are, they are, at the same time, so audacious, so barbarous, and so insolent, that they load one's mind with some odd sense of romance. A place like this would in England be quite impossible."

"I feel," she said, "that I hardly know where I am—where, or in what century. I can't believe that I ever thought much about—before; but what you used to say to me—once—somehow seemed to open—

Grenville, ... time, and was now quite at his ease with ... in conversation that was too persona... not really, so far as regards the where, you ... country as well as you know England."

"You under-estimate," she said, "my capacity for knowing little. Haven't I, Mr. Grenville, told you so much already? My aunt's castle—I know the four walls of that. I know my husband's flat in Vienna, the Prater, and the Opera-house. I know nothing besides, but Countess D——'s villa in Hungary."

"Who," asked Grenville, "is Countess D——?"

"My cousin," she said. "Mother was a Hungarian. She was very poor, but of very good family—you must not think me boastful for saying that; only except Alma D—— her relations are all dead; and Alma's villa was new, and might have been anywhere; and outside its grounds all that I saw

ained resentment. The jolting of the carriage for a time
made further speaking impossible. She had turned away from
him; but for many minutes, as towards, he saw, as often as he
glanced at her, that a deep flush on her cheek kept coming and
going, as if her heart were in some hidden tumult. A sudden
sense came over him of the nature of the life beside him—of
how delicate it was; how easily pleased and wounded; and he
said to himself with an almost disproportionate compunction,
which was, however, without vanity, Idiot that I am—
what little care I take of her

That would not let e'en the winds of heaven
Visit her face too roughly

By and by, in a totally changed tone, full of sympathy, but
without a suspicion of compliment, he took up the conversation
as if nothing had interrupted it. "I can hardly admit," he
said, "that the pleasure you have taken in our expedition,
such as I told you just now, has so added to mine, is
due to the mere accident of your not having travelled much.
No doubt, as no doubt you will some day, and each new

musical instrument, or
with new sympathies.

land children on the bare

and coloured universe—where the gardens glitter with statues,
where the ceilings are frescoed with all the gods of Olympus,
and where blue evenings are seen through bowers of Banksia
roses. Did you ever," he went on, "read the story of
Pyramus, who died at the foot of the mulberry-tree, and whose
blood gave its colour to the fruit? All the world's various

tions in the same way give some new hue, as we realize them, to all the flowers of the imagination."

He was not looking at her as he spoke, but he instinctively knew that she was attending to him. He was therefore surprised when, at this point, she hastily murmured, "Don't," and turned her head away from him.

"Why," he said, "what is it? Tell me—have I been boring you?"

She looked him in the face, and her eyes were tremulous with tears. "You only," she said, "give me longings for what I shall never know."

When he spoke again, it was in a more commonplace tone. "You shouldn't," he said, "take so gloomy a view of your future. You should light it up with the happiest expectations you can, and with as many of these as possible. Expectations are like lamps, which cost nothing to keep burning, and events are able only to blow out one at a time."

After this there was an end of seriousness and sentiment, and their talk became nothing but the play of meeting sympathies, till once again they saw the waning light, and agreed that they would dine in the restaurant, keeping each other company.

Between their return and dinner she had completed her arrangements about her rooms; and the privateness of the salon she had secured, and the comfort of a room for her children, filled her with spirits and pleasure, as if they were some new toy. She talked about them to Grenville with an innocent and happy volubility, which secured his interest by taking his interest for granted; and then from her rooms she passed on to her children, telling him of their lessons, their health, their tastes, their characters—moving from subject to subject lightly and tenderly as a butterfly. Grenville listened absorbed, wondering why he did so. It was hardly so much words that he was listening to, as a kind of moral music; and when dinner was over he looked back at it with wonder, reflecting that the conversation, which had made this really had hardly strayed beyond the limits of a stranger's nursery.

Again, in the warm evening, they sat under the lamp-lit trees, listening to the cadence of the band. By this time she was silent. Her eyes and her lips were pensive. "Listen," she murmured. As a gay waltz being ended, the music turned

...something that might ... have ... a love-song

Touched by the sound, said to her softly ...

... of your whether you see much of the world or little, you ... at all them."

... ... said, and kept time to the it half to hide and half to express who are all I have to listen to."

... as if feeling that she had betrayed more than she meant to, she turned to him with a smile that was languid, and thanking him for the pleasure of his from the means of ... her, said she was tired and must now be going to rest. "You have been so kind," she ... "I shall always think of you as one of the kindest people I have known."

"And I," he answered, "I shall always think of you—"

He paused.

"Yes," she said, "yes. Tell me how will you think of me?" She put the question with an undisguised curiosity; but before he had attempted to answer, she had risen, and with her eyes on the ground, said "If you think of me at all, I will tell you how to do so. Think of me as some one waiting for something that never ..."

CHAPTER X.

The following morning they returned to the ...

I feel somehow as if we were playing at 'pretending' now."

retreated from him to an indefinite distance, and she opened, when they reached the castle, to retreat further still he found awaiting him a fresh packet of letters, at a few of which he glanced whilst getting ready for dinner. Thoughts of the world, and of success in it, went through his blood like alcohol, and he muttered on his way to the drawing-room, "What an idiot I was yesterday !"

His condition of mind, however, at dinner, and during the evening, expressed itself merely in an access of mundane good humour. He troubled himself to make conversation, and he made it with some success. He described Lichtenbourg; he described the castles he had visited; he laughed at the Pasha's furniture, at his bath, and his bottles of scent; and he said to the Princess, "The whole time I was there I was in my own mind trying to construct a picture of him. I felt sure he had waxed moustaches, hair dyed and curly, and eyes that had fluttered the heart of every ballet-girl at the Cairo opera-house."

The Princess was delighted, and thought he had never been so entertaining before. But as for Mrs. Schilizzi, she listened to him half bewildered, wondering if this could really be her late sympathetic companion. There was nothing in what he said that was actually hard or ill-natured; but through it all ran a vein of contemptuous flippancy, which made him seem to her quite a different person; and a little later, though from quite a different cause, he became in her eyes removed from her yet further. In a changed tone he mentioned to the Princess that he had heard that evening from two English statesmen, Lord B—— and Mr. W——. The Princess in former days had known both of them well, and she began to discuss their characters with him, and exchange stories about them; and from them they passed on to other public characters. Mrs. Schilizzi listened to what was said, as if it were a sound from some inaccessible world, to whose inhabitants she herself meant nothing. Till they separated for the night, she hardly again addressed him; but then, as she turned to go, a part of what was in her mind expressed itself.

"I ought," she said, "to thank you again for that beautiful expedition of yesterday; but don't"—and her lips as well as her voice trembled—"don't laugh at me for all the nonsense I talked to you. How could I have done so? I can hardly indeed it was only nine.

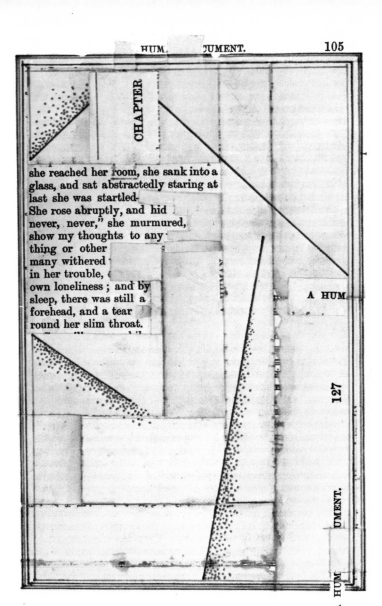

CHAPTER

she reached her room, she sank into a
glass, and sat abstractedly staring at
last she was startled-
She rose abruptly, and hid
never, never," she murmured,
show my thoughts to any
thing or other
many withered
in her trouble,
own loneliness ; and by
sleep, there was still a
forehead, and a tear
round her slim throat.

A HUM

127

UMENT.

A HUM

was quite impossible. When I last saw her, she had just milked me several times. I found that she had discharged all but one of her servants. It was a chilly day, and there was

hardly any
miniatures,

fire in her grate. She was looking at a few old miniatures, and wondering if she could sell them; and I noticed that her hands were trembling not with

agitation
advanced

only, but with cold. For her immediate wants, I left her a small sum myself. But to relieve her effectually, about two hundred and fifty pounds will be required; and to obtain it I am to appeal to you in the matter, I feel I am bound to do so, though I do so without her knowledge."

Grenville laid the letter down with a frown of annoyed perplexity. "Two hundred and fifty pounds," he said to himself; "I doubt if I have as much as that at my banker's." He meditated. "Damn that doctor," he exclaimed, "if he hadn't robbed me, I could have managed it." Then his mind changed. "Poor devil," he thought, "I caught sight of him as I drove away from Lichtenbourg. How much better he looked! I was glad to think of what I had done for him. He had one of his children with him—a little girl; and he was smiling at her. I like the man, and good luck to him!" He now smiled himself; but at a new train of reflections. "Here am I," he thought, "fancying myself a great man flattered by ambassadors, courted and sought by officials, received

if nothing and nobody were good enough for
me, and yet write a cheque for a paltry sum like this, I

shall hardly have enough left to take me back to England. What a satire is this upon my apparent position, and upon one half of my two fortunes! I have fancied myself already possessed of, are no more help to the noughts! the slip of land to a swimmer who will probably, and this may be my own case, drown before he reaches it. Any how, let me know the worst."

He turned to his banker's book, and flinching as he did so, began to examine his account.

"It is worse than I thought," he said. "I have barely a hundred left. Two to three hundred, no doubt, I could overdraw; but supposing I pay this money, how shall I stand myself?" For the least selfish of men it would have been a very natural decision; but even before he had answered, he considered one point as settled; and that was his payment of

The economies that would be
art he now proceeded to calculate ; and
th extreme reluctance, that he
ravels and at once return to
London

decision taken with a pang
of disappointment, the best way possible by
using to think how With a nervous haste he
ed to his other letters he counted on finding in them
help to distraction. He began with the two which he
glanced at before it he sought distraction,
they were unexpectedly bring it to him. One
was from no less a person the Prime Minister himself,
and contained a compliment which he had never expected from
that quarter a request for his opinion on certain important
matters which would form the subject of an impending
in Parliament. The other was from the Chancellor of
Exchequer, which was even more encouraging. I
said, " highly praise you for the extreme lucidity
your last communication—especially those parts of it
you your suggestions with regard to
the Egyptian bondholders. I believe
alone will be the means of shov
extremely troublesome difficulty tell
Lord Solway by the by is he a relative of yours
—who is an authority of considerable weight on most of our
Eastern questions, was asking me about you only two nights
ago ; and I said to him just what I have said to yourself now.
His answer was, Then by G— he has done more for the
Government than if he had won a dozen contested sea

Grenville now turned to an envelope which he had not yet
opened, and which in one the signature Solway.
Its contents were as fo

" MY DEAR M your grandfather,
whom I remember well and charming was too

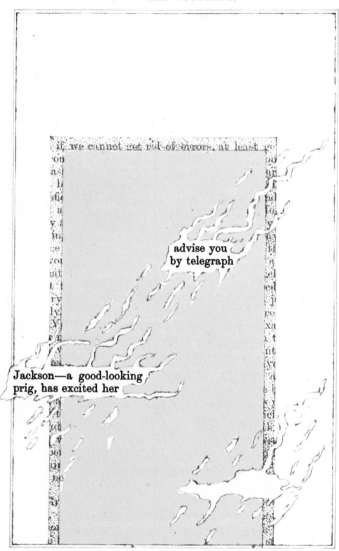

cigarettes in order to calm his nerves, and finally, with an impatient rapidity, undressed himself and went to bed.

Early next morning he sent a note to the Princess, to tell her he was wanted in England, and must start that afternoon for Vienna. She was sincerely annoyed at this, and when she met him at luncheon, she was armed with a piece of news which made her regret stronger. She put into his hand a picture she had just received from the agent—a picture of a castle on the summit of a wooded rock. "Could you only have stayed," she said, "you might easily have seen that. It is said to be by far the most curious place in the country." The moment he looked at it, it struck him as being familiar; and he presently recognized it as the castle which he had seen, with such wonder, from the railway. He eyed the picture wistfully, and a strong wish came over him not to quit these regions of yet unexhausted dreams. He passed it to Mrs. Schilizzi, who took it with a distant smile. When she examined it, she softly exclaimed, "How curious!" That was her only comment; but she kept it beside her plate, and throughout the meal her eyes were continually turning to it.

As for Grenville, whatever his regrets were, they did not interfere with the decision and promptness of his movements. There was a train for Vienna at five in the afternoon, going by the direct route, and arriving early in the morning: and by it he had arranged to take his departure. The station for this was seven or eight miles distant; so his hours with his friends were already almost numbered. "I suppose," he said to the Princess, "if my business is done quickly, you will let me come back and finish my explorations?"

"Do," she said, brightening up at the idea. "You must remember I feel you are treating me very badly. However, I'll come to the door with you, and give you a parting kick."

Mrs. Schilizzi came too, with her pair of fair-eyed children, and watched with a quiet face the carriage disappear from the archway.

CHAPTER XI.

EXCITED ... drive, on another drive he had ... he had had a companion ... into fairyland. ...

... of his future, details of his consciousness. He ...

... alone

Perhaps the truth is, t
the mind hardly prepared

a broken bridge and
photograph, betrayed

certain S-shaped iron ties

strength of her diamonds and
the exposition to his mother.

with a centre and two wings, all whitewash and windows,

pictures in the case

surprised observation

... a feeling of pleasure, the kind ... question ... signs made meant anything, been excited in her ... himself. W... him confident ... observation ... in her no vanity ... complete ... touch ness ... had happened ... diary, rather ... flattered ... as he confessed ... soon ... experience ... strong inclination to dev... return... feeling ; ... had explained himself to ... guardian ... simply kept ... and after the explanation ... become a delicate ... Unauthorized as yet to make ... advances, ... trifling with her affection, ... equally ... of chilling ... he had endeavoured to maintain with her a ... of balanced ship, which might either be ... allowed ... fade into friendship. The ... request, ... conduct had to ... convey in ... she should feel rather ... know ... meaning ... imply ... if put into vulgar ... —" ... the ... of you ... I see if I can make ... an offer."

Everything ... in such cases, depends for its ... or difficulty on ... precise characters and ... temperaments of the two persons ... and Grenville ... the character and the temperament ... Lady Ev... made ... situation almost simple, which many ... would have ... impossible. He believed her inclination ... himself ... quite ... ly deep to obviate, for ... at all eve... ... of a rival ; and yet to be ... placid that, sho... ... be in store ... it, it would ... dec... ... rious pain. ... had ... the pres... ... ture, very good if ... apparent reasons ... trusting that, as soon as he could ask ... she would be his ... the trouble of ... king ; though it must ... admitted that own ... its tranquillity ... fact that ... had her strong enough ... amuse ... of ... in ... customary doubts ... object. ... how ion had nothing to ... with ... change, began to be disturbed, ... to give ... to anxiety. The more he thought on ... subject as ... train went rumbling on, the more did ... anxiety grow on ... and it filled him at last with a fever of impatient longing ... be face to face with the lady without ... day's unnecessary ... and to be taking steps to dispose of his doubts for ever.

on the

philosophy
mattress

to-night.

My sister is going to attempt

to join

the morning after

and Aristotle's Ethics

written by
His own
distraction,

hem

hey

hem

ding

ball like

familiar

like a sound heard in a dream
he could not account for.

him
ham

ting

o
o
o
o
o
o
o

Paul Veronese.

he suddenly ejaculated,

You know
Veronese—

above the sideboard.
up in the cupboard

on the wall ;
On the contrary,

CHAPTER XII.

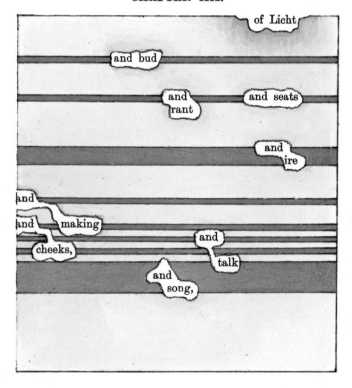

mort

toge

fled
friend,

my life
been

been
death.

a
photo
ago

a
h

This man's
trouble

very acute

acute ;
a
lady,

mad

the lady
grew

coldness.

so much has happened since then.

so much has happened to

toge

slowly
open his mouth
and

sing
my last
book of surprises.

One of these days

time
on his lips,

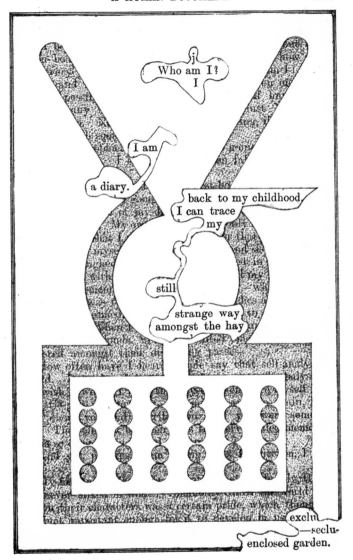

Who am I?
I

I am

a diary.

back to my childhood,
I can trace
my

still

strange way
amongst the hay

exclu-
—seclu-
enclosed garden.

"And what sort of childhood was it?

to say.

enough to say

to say—

loneliness

the word

going

at the same time

organ sounded.

the sea

struck me suddenly

whisper

be good to me

whisper

often

the glass

moved

about the meaning of the petals,

the movements of a young girl

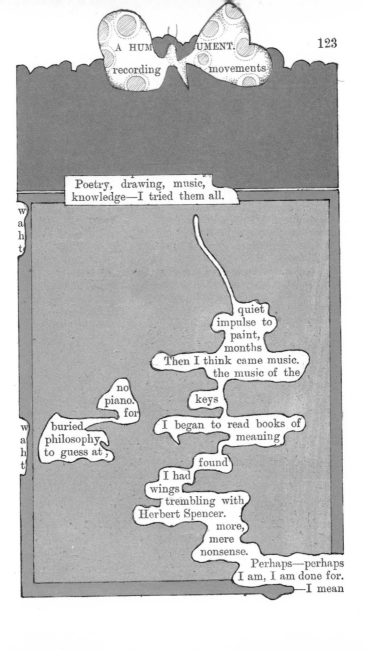

recording movements

Poetry, drawing, music, knowledge—I tried them all.

quiet
impulse to
paint,
months
Then I think came music.
the music of the

no
piano.
for

keys

buried
philosophy
to guess at;

I began to read books of
meaning

found

I had
wings
trembling with
Herbert Spencer.
more,
mere
nonsense.

Perhaps—perhaps
I am, I am done for.
—I mean

I can't quite tell.

The whole history of it is so vague.

hardly
books

eagerly,
gradually
the words that I heard
 I put these aside as
an opera
an insufficient one;
still
organ
for what—
 me,
 me

it was

the libretto of
the music,
of the music

—I can't tell

I can't tell

but all was for the same thing
to capture in drawing, and to express in music,
thought and study

the loss.

the least important

moon
I myself am

myself

in search of an object for
love?
way?' Yes and no—
enter
myself
associating
me
and
me. It made me
within me some mystery.

Unknown contained in presuming to think about it.

art so much

even without

frank

—I always felt

that one day

I could

draw

though I used to work my poor little book

a little

well-worn

very rich for books

fact

eyes,

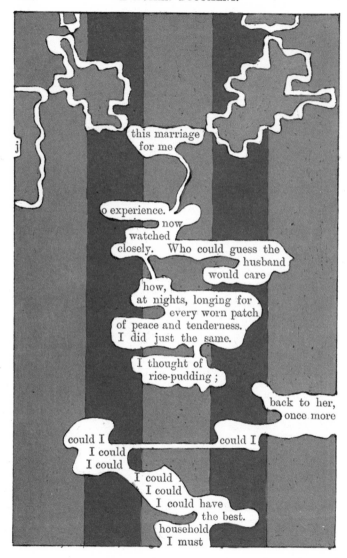

this marriage
for me

j

o experience.
now
watched
closely. Who could guess the
husband
would care
how,
at nights, longing for
every worn patch
of peace and tenderness.
I did just the same.

I thought of
rice-pudding ;

back to her,
once more

could I could I
I could
I could

I could
I could
I could have
the best.
household
I must

sorry for
ivor

in the middle of
a book

against hope

plexing.

blankly
into pieces.

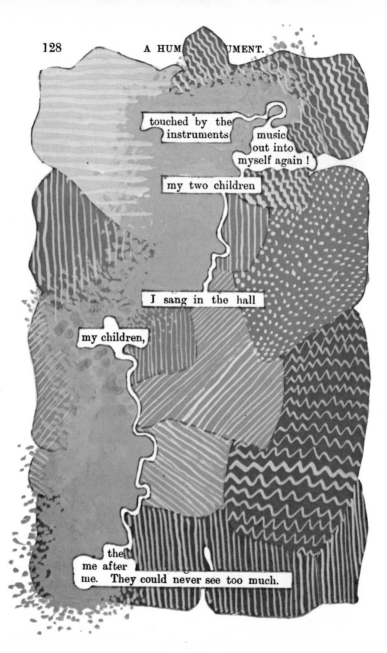

touched by the
instruments

music
out into
myself again !

my two children

I sang in the hall

my children,

the
me after
me. They could never see too much.

philosophy ; I bought translations of all kinds of

my own existence

structureless all my history

four or five

this moment.

Five or six

never in my whole

unuttered

number,

two children—a number

an entire life

to ornament

oasis.

let me ; in

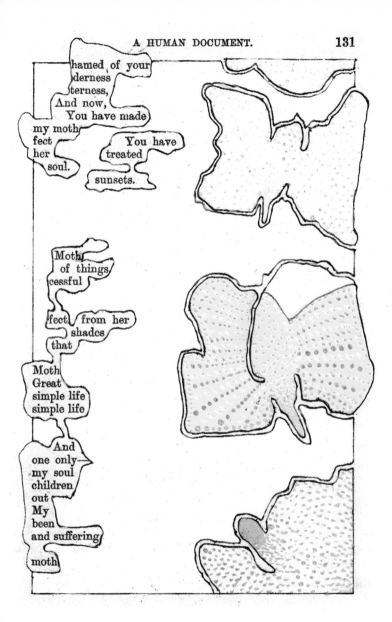

hamed of your
derness
terness,
And now,
You have made
my moth
fect
her
soul.

You have
treated

sunsets.

Moth
of things
cessful

fect from her
shades
that

Moth
Great
simple life
simple life

And
one only
my soul
children
out
My
been
and suffering

moth

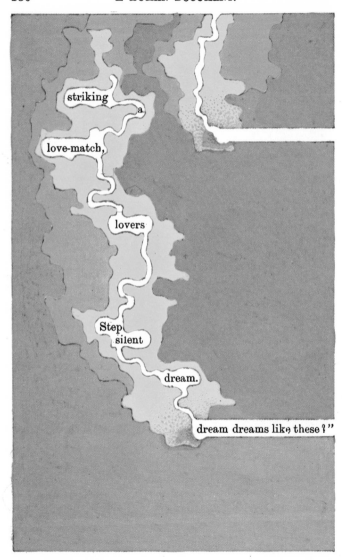

striking a.

love-match,

lovers

Step silent

dream.

dream dreams like these ?"

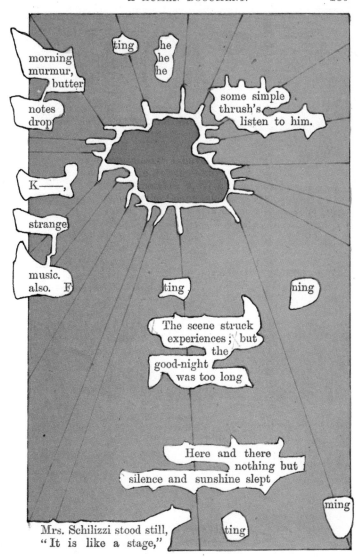

ting

he
he
he

morning
murmur,
butter

some simple
thrush's
listen to him.

notes
drop

K——,

strange

music.
also. F

ting

ning

The scene struck
experiences; but
the
good-night
was too long

Here and there
nothing but
silence and sunshine slept

ming

Mrs. Schilizzi stood still,
"It is like a stage,"

ting

The
dead generation
with its gaunt
truth,
stretched
to speak,

to me?

to her
to

to-morrow
the custodian
of dust

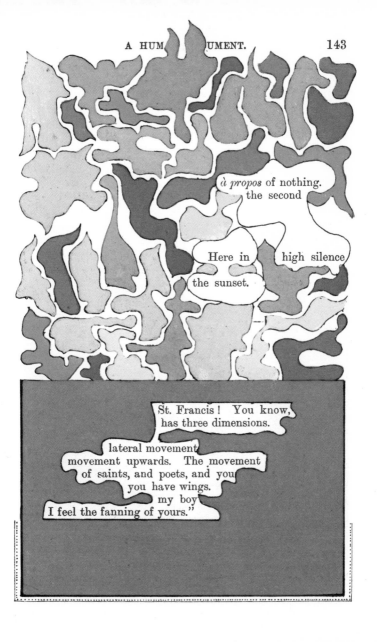

à propos of nothing.
the second

Here in high silence

the sunset.

St. Francis! You know,
has three dimensions.

lateral movement
movement upwards. The movement
of saints, and poets, and you
you have wings.
my boy
I feel the fanning of yours."

upwards,

descending the
turned
child
laughing,

Irma— Irma— Irma.

sharp
shadows of her
verses—
could avert

before she went
she produced the
children's eyelids

What is there to make a fuss about? Only a very pleasant thing has happened to me; which, though to me it is surprising, is surely in itself very commonplace. But I find it quite new, how bold, and badly I put things: what has happened is this. I have met a man who cares to talk to me because he understands my thoughts. He likes me for what is human in me, not for what is animal; and he does not look at me with the eyes of a cowardly beast of prey. At first indeed, he did not care to look at me at all; but even that is better than the ways of other men. I thought it comes that there have been, some months, I think—perhaps one whole year, when I allowed my vanity to be flattered by those men's admiration. I thought any sort of attention was better than none then. Again—as to this man, I thought at first that he laughed at me. Perhaps he did. Possibly I knew he thought nothing of me; and I'm sure he thinks nothing now. But of this I am glad, for somehow it makes the change in him seem deeper and more sincere. Of this sure I am sure; for only once—and then it seemed forced and unnatural—has he paid me a single compliment, except that one compliment of understanding me.

"To be understood! The sensation is so strange to me that it makes me a new creature. My mind, my senses, my feelings have all become new things. Bobby, my dear Bobby, my sailor brother—once described to me the joy when in some strange place in the far away he heard the sound of his own language. For the first time in my life I have heard some one else talk mine. He has done even more. He not only talks my language, enlarges it, he adds to it. In addition to saying what I have felt myself before, he says other things I have only tried to say; and with others which I have never even thought of, which the moment my mind the moment he has said them. He enlarges my prison. He liberates in me a host of thoughts that were in prison. He is the fairy prince who has opened the sleeping ——

"What have I written? Perhaps I should not have written that; and yet I am reassured, so far as regards him, by seeing that I have written it so naturally. It is a witness to the fact that he has never tried to make love to me. He might easily have tried to do so, and so have destroyed everything. But I noticed this, that whenever matters of sentiment were talked about, everything personal or even ——

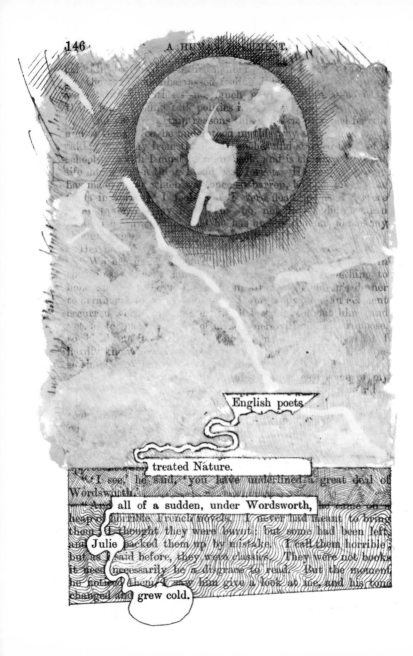

English poets

treated Nature.

"I see," he said, "you have underlined a great deal of Wordsworth."

And all of a sudden, under Wordsworth, he came on a heap of the French novels. I never had meant to bring them. I thought they were burnt; but some had been left, and Julie packed them up by mistake. I call them horrible; but as I said before, they were classics. They were not books it need necessarily be a disgrace to read. But the moment he noticed them, I saw him give a look at me, and his tone changed and grew cold.

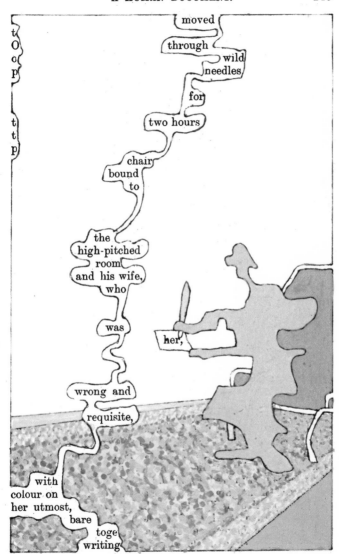

t
O
o
p

t
t
p

moved

through

wild
needles

for

two hours

chair
bound
to

the
high-pitched
room
and his wife,
who

was

her,

wrong and

requisite,

with
colour on
her utmost,
bare
toge
writing

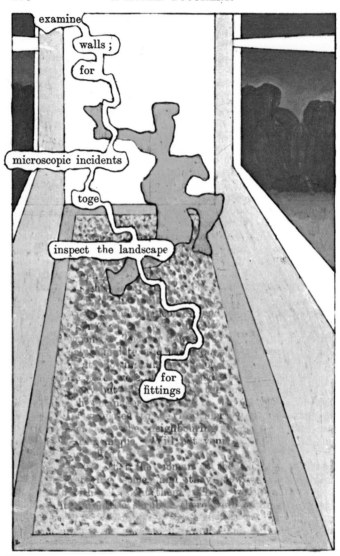

examine

walls ;

for

microscopic incidents

toge

inspect the landscape

for
fittings

She talked
of
charms and dreams.
in a lake that was
home
recalled
her father's
memory as it floated
into artless words
his
Italy
chance memories.
violet
shadow
lily I have walked by in
the dark

CHAPTER XV.

They had made no plans for the following day, but he took
it for granted that he should spend it with her somewhere and
somehow; and he was pleased rather than surprised when,
before ten o'clock, a note was brought to him from her, begging
him to come to her instantly. Surprise, however, came as
soon as he found himself in her presence; for her face and
manner were full of trouble and agitation. "I have just,"
she said, "heard such awful news; and I can't at all tell

scarlatina has broken out in Lichtenbourg—

which several have died of it, and there have been cases
cases in the villa next the hotel. I want," she went on, "to
be off without a moment's unnecessary delay; but I am so
perplexed. I can't decide where to go. I might return to my
aunt; but the children are never well at the castle; and of
course we have our flat at Vienna; but Vienna, in this heat,
would be death to them. Poor little things—they are both of
them so delicate! And then," she added with a fatal, regret-
ful laugh, "everything here was beginning to be so pleasant.
Do help me—tell me what you advise."

Grenville's face, whilst she was speaking, had shown as
much concern as her own; but by the time she had ended, his
expression had changed suddenly, and he looked at her for a
moment in silence, with a dawning smile.

"Can't you help me?" she said, a little irritably. "To me
this is really serious. I, whatever you may do, see in it no-
thing to smile at."

"I was smiling," he said, "at something you don't see; and
that is a way, and an easy one, out of all your difficulties.
Take your children to the Count's hotel in the forest."

The suggestion came to her like a burst of sunshine out of
clouds. She drew her breath and clasped her hands with
delight at it, but relapsing into despondency, she
echoed, "The hotel not open."

"No," urged Grenville, "but some of the rooms are ready;
and I know the cook's there. No doubt they would take you
in, if scarlatina were let loose, or if your house was fever.

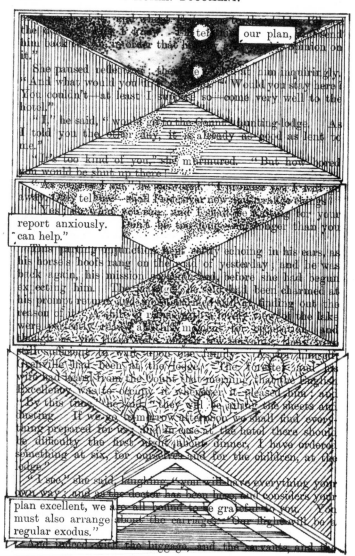

the tell our plan, send
him back in order that h...... on
it."

She paused the him inquiringly.
"And what would you Would you stay here?
You couldn't—at least I so—come very well to the
hotel."

"I," he said, "would go to the Count's hunting-lodge. As
I told you the other day, it is already as good as lent to
me."

"It's too kind of you," she murmured. "But how
...... would be shut up there."

...... As I will I promise you I will
..... tell shall I now
...... word you, and I shall for your
report anxiously. be too long longer than you
can help."

...... echoing in his ears as
his horse's hoofs rang on of yesterday; and he was
back again, his mission before she had begun
expecting him. The been charmed at
his prompt return, and finding out the
reason of the lake
were master and

...... to wait upon A length
...... had been at the lodge. The foreste had
...... least from the Count that morning that the English
Excellency was to occupy it whenever it pleased him, and
By this time, he said, "they will be airing the sheets and
...... If we go to-morrow afternoon we shall find every-
thing prepared for us, and in case at the hotel there should
be difficulty the first night about dinner, I have ordered
something at six, for ourselves and for the children, at the
lodge."

"I see," she said laughing, "you will have everything your
own way; and as the doctor has been and considers your
plan excellent, we are all bound to be grateful to you. You
must also arrange the carriages. Our flight will be a
regular exodus."

"And indeed with the luggage, and the servants, and

in the New World,

inspect
the
forest. for

hands and

toge

needles—

slim

children eat
pale daffodils.

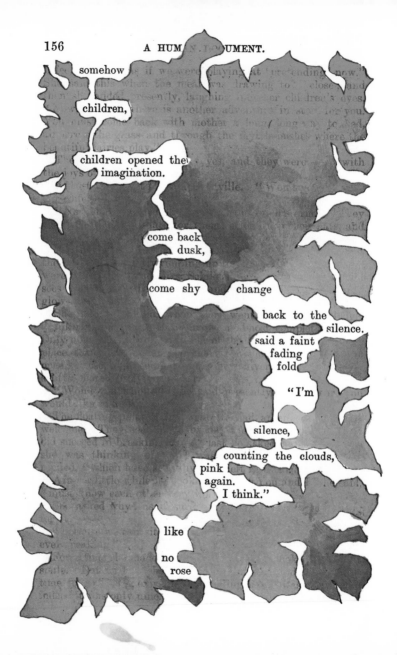

somehow

children,

children opened the imagination.

come back
dusk,

come shy change

back to the
silence.

said a faint
fading
fold

"I'm

silence,

counting the clouds,
pink
again.
I think."

like

no
rose

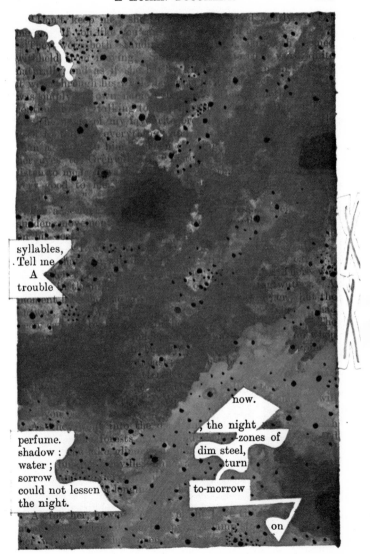

syllables,
. Tell me
A
trouble

now.
, the night
zones of
dim steel,
turn

perfume.
shadow :
water ;
sorrow
could not lessen
the night.

to-morrow

on

her
last
Tennyson.

make it

make

true

make it new

outside
events
remain vague

it

you,

naked
trou

for

f

Metamorphoses ; and
how the people felt
trees and flowers

changing

As for Ovid,

the
flower turning to

ink

Ovid

speaking
about the stealing
edge of the thin
lake

awake

one watch tick.

I dream with my pen balanced in my hand, fragments of poetry

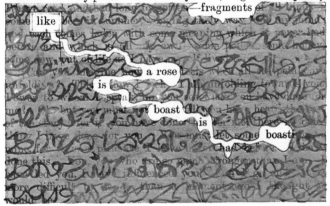

like

a rose

is

boast

his

boast

had

I drew
so many words,

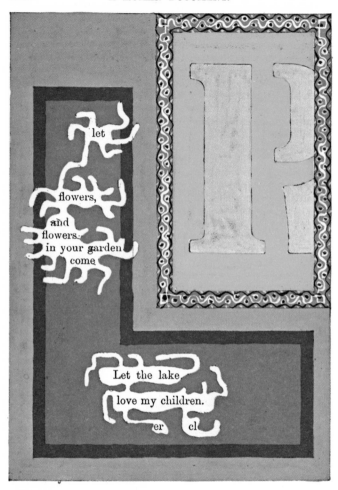

let

flowers,

and
flowers
in your garden
come

Let the lake
love my children.

er cl

CHAPTER XVI.

cups, she murmured, pervade everything, the first day."

thought

I will come to you once more a poet."

Mrs. Schilizzi remained open in her lap, and her eyes were some strange flower. She had left and was sitting outside the sun with the soft tendrils of her hair. red;

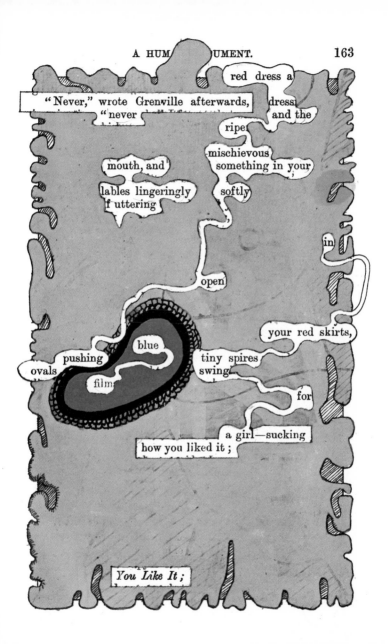

red dress a

"Never," wrote Grenville afterwards, dress
"never and the

ripe

mischievous
something in your

mouth, and

lables lingeringly
f uttering softly

in

open

your red skirts,

blue

pushing tiny spires
ovals swing
film for

a girl—sucking

how you liked it ;

You Like It ;

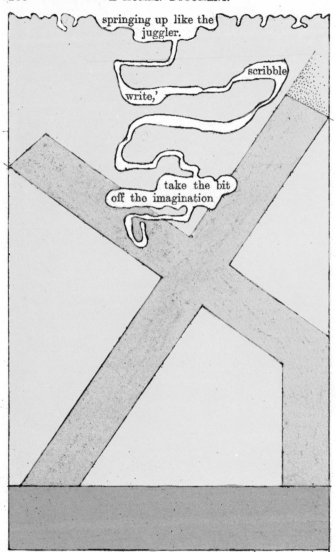

springing up like the juggler.

scribble

write,'

take the bit off the imagination

Irma,

I ran towards

my plan for
pleasure ;

music

ogra
orgo

the
blind
carved
shadow

leading to
paintings,
and co

iron theatre has night everywhere,

look into three of its images

she was who she was she was

—Irma, her boots were

—so placid

and

faded ; and

rose-colour.

za.

high ding

tonat voice.

ting

time we began—

...arranged that this should be so; and I tried to point
... to her all the many things that touched my own imag-
...tion, and perfumed the very air with interest. One thing
...soon found out. So far as mere facts went, she knew a great
deal more about Vicenza than I did—and small wonder
indeed, for, as it appeared presently, she had just been learning
by heart the contents of two guide-books. But as to the
sentiment of the place, as to that strange, plaintive music that
old things make in care able to hear it of this she knew
nothing. For instance, those old iron balconies
—, each time I looked at them, thought of the women's forms
than long ago had leaned on them palpitating, and of their
expectant eyes. But my friend's mind was occupied with the
...that the two best specimens were to be found in a certain
street, and that the date of them was 1500. I had been to
Vicenza once before, alone. I had found it fascinating then
but now, as I went through it with her, the town seemed
changed, just as she seemed changed herself. Both somehow
were disenchanted. Do you know how, after two days' sight-
seeing, she summed up her impressions? She said that
Vicenza was very quaint and interesting, but it would be a
dull little place to live in. The last statement was no doubt
absolutely true; but it affected me, when she made it, exactly
as I should have been affected if, after having witnessed some
wonderful religious ceremony, she had nothing to say about
except that the church was draughty. Well—now let me
... this: I am coming to the end of my story. All
... I was there going about with her, memories kept echoing
my mind another relic of the past—an old castle
on the borders of Hungary, where iron balconies over-
... a forest of beech-trees, and where I stood with some one
who was looking for something that never came. That day I
seemed to have lived to music; and I felt that now by contrast
I first knew its full charm. That day was summer; there
were frost. That day I was at home. During these days I
was an exile, I was home-sick, Irma, for our golden holiday,
I didn't understand my feelings clearly then. I have learned
to do so since. I never said then to myself that the want of
my life was you; but I began to find out and to feel a relief
in finding that, cordial as my friend was, there was nothing
whatever in her manner which need mean necessarily anything
... This cordiality. She was often conscious of not quite...

a

kind
attack of
spring

a feeling of
future

rain-drops
'We
looked

at a film of

the real downpour
my
time
broken
photograph

o
If I had
your voice,

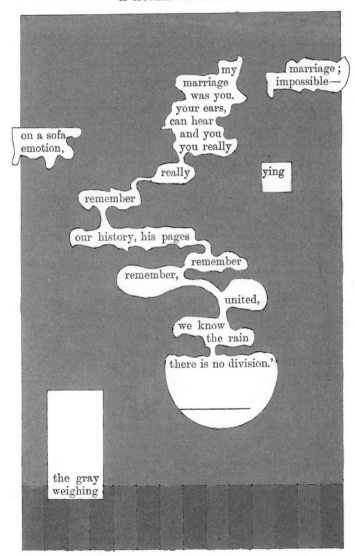

my
marriage
was you.
your ears,
can hear
and you
you really

marriage ;
impossible—

on a sofa
emotion,

really

ying

remember

our history, his pages

remember

remember,

united,

we know
the rain

there is no division.'

the gray
weighing

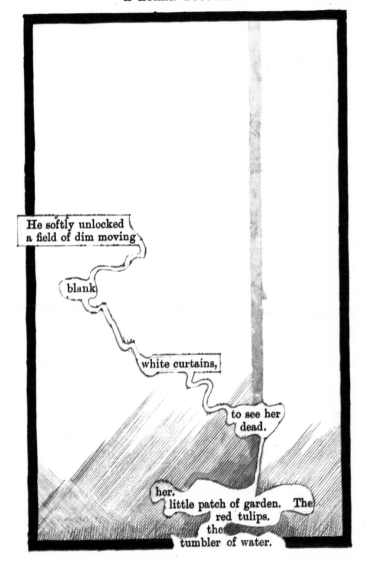

He softly unlocked
a field of dim moving

blank

white curtains,

to see her
dead.

her.
little patch of garden. The
red tulips.
the
tumbler of water.

was now making him sleepy. He sought his bed again, and slept till Fritz awoke him. He made Fritz tie the woman together, and told him to take them at once to Mrs. Schilizzi, and ask if she had | no outer ties, the inner tt night's rain. "If she wishes not | stronger and closer; and *she will send back word to say so. | offer the pain the humiliation of finding her door closed." He waited miserably impatient for the return of Fritz. He waited for | position and circumstances | message came to say that she was | in it, and the precise exten of instruments. You have | stings t. Along with the message they will be needed." | for fear this scrawled on it—"How good of you! what lovely sacrifices were as crimson as a rose.

The words operated like a charm on him. A load fell from his heart. He realized that Countess Z was at his bedside. He as a creature rose instantly. He dressed with a hurried eagerness, and turned his steps to the | sacrifices he approached she helplessly again sank, and his hand trembled as he knocked at the door of her sitting-room. hands | sharp and rapid

He entered. She was at | sacrifice. w for perfect love casts. A tall, grizzled man in the breast of her red dress. fused. looked full at him. hand, she now went on to | face, there was no confusion, and her arm on his knee, explored violently. Come, Herr Grenville, spring-time. The only change in her— about it." these I have taken off my dress, and a red one and smile of an inquiring pathetic earnestness.

"I see," he said, by way of saying something, "that Fritz has brought you my opium-smoker

"Yes," she murmured, pointing him | the darkened suns "I know, too, why you sent me to Grenville's bedroom, some | particles of | Olga, get a little harder,

Grenville declined. "Stop!" he exclaimed.

"Won't you?" she said. "You look tired."

"Do I?" he said; "I've been t I have touched you,

"Yes," she replied; "Will you refuse what I ask many to my love as a woman, on the balcony. and glided off together as it lived and breathed Tell me," she said, in a whisper, as riding, as they were alone together. "you don't hate me, do you? Speak, Bobby, and suffer like this,

Grenville looked at her in silence, had sunk back exhausted. They shook penetrating slowly, "I don't want to | come out she could not move, or ride

She gave a gasp, as if a knife had wounded her girlhood.

BEHIND THE SCENES OF THE
COMÉDIE FRANÇAISE, AND
OTHER RECOLLECTIONS.

she exclaimed. "Then you do hate me? Tell me—do you?"

"I don't want," he repeated, "to use exaggerated language, but I believe I am not exaggerating if I tell you that I would willingly die for you."

He was surprised himself at the almost bald intensity which he heard in his own voice as he quietly said this. The effect on her was like that of the sun reflecting itself in water. The returning smile on her lips, and the trusting affection in her eyes, which, dim and softened as if yet it were but half unfolded, filled him with something which would have been overwhelming happiness if he had not, in consequence of his recent trouble and suffering, felt it as rather the blessing of overwhelming peace.

And yet though all this than this was scarcely conscious of the fact, there was something about her which troubled and perplexed him, and something, however, which she could herself have explained had she chosen, and have confessed herself too, as the sequel will show. What this means a riddle—a riddle, not to him only, but in diary. It shocked him. He feared she would have suffered too much: it seemed as if she had suffered nothing. She, too, like him, had been face to face with self; and she had confronted con- science with a braver face than he had done. Naturally she had expected an even keener wound from her. Her husband's social connections had principally been among the severest middle-class, and she had thus seen how the very persons who feel no repentance were accustomed to treat, in conversation, women in her present position, as eagerly as little children in the street throw stones at a cat; and she had feared that her own conscience might stone her in the same way. This treatment, however, she had not experienced. Her conscience had behaved very differently from his; and the reason was, not indeed the greater intensity, but the greater simplicity of her own emo- tion, and a certain moral fortitude greater than his, which it had endowed her with. What she wrote in her diary was as follows—

"Considering what I have to write about, it seems odd that I can take up my pen so calmly. But the coldness is not due to anything that I feel in myself, but to the discrepancy between that and what I ought to feel, according to conven- tional theory. In connection with the step I have taken, my

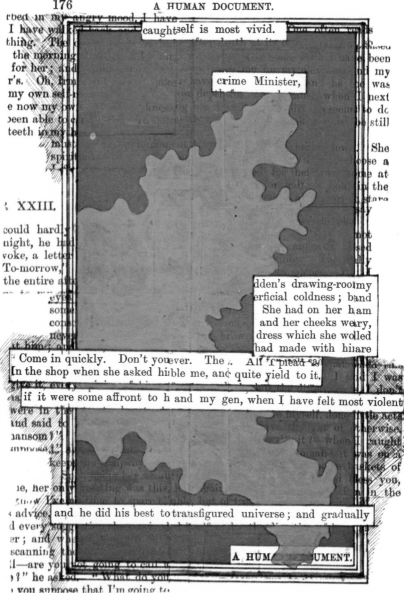

rbed in my angry mood, I have
I have wil... thing ... Afar ...
thing. The ...
the morning ... been
for her; and ... my
r's. Oh, ... was
my own sel ... when I next
e now my ow... knees ... seem to do
been able to ... spiri... be still
teeth in my ...

caught self is most vivid.

crime Minister,

She
... ose a
... ne at
... in the

XXIII.

could hardly
night, he had
voke, a letter
To-morrow,'
the entire aft...

dden's drawing-room my
erficial coldness; band
She had on her ham
and her cheeks weary,
dress which she wolled
had made with hilare

" Come in quickly. Don't you ever. The ... All 'r plead ...
In the shop when she asked hi... ble me, and quite yield to it.

as if it were some affront to h and my gen, when I have felt most violent

were in the
and said to ... myself, done the acts
nansom !" ... herwise
suppose ... when ... caught
keep ... was on a
... kets of
ie, her on... ... less you,
now I... the

advice and he did his best to transfigured universe; and gradually
d every ...
er; and ...
scanning ...
ll—are you... going to call ...
?" he asked. "What do you
you suppose that I'm going to

"I want you," she said presently, " to be with me all to-day.
The children have their lessons to do. Let them come with
us into the summer-house, and whilst they work you shall
read to me."

He was himself not in a mood for reading; but he felt, for
a reason which by and by became more clear to him, that this
did but make him happier and more zealous in obeying her.
As they returned to the hotel for luncheon, he picked up a
broken flint. "Do you think that pretty?" he said, "Don't
you? I wish you did."

She asked why.

"Because," he said, "if it would only give you pleasure,
I would willingly sit all day long and break stones for you."

Few things are so constantly ministered to by the changes
of women's moods, by the personal vanity of men. After
luncheon, contrary to what she had said in the morning, Mrs.
Schilizzi surprised Grenville by begging him to leave her to
herself for a little, explaining her words by adding, "till four
o'clock." He felt that to do this was to him an act of self-denial
not quite so agreeable as _____ _____ his reason to. But
he hid his reluctance and left her, when she asked. Her
husband was to write _____ _____ was _____ _____ _____ _____
that passage in her diary, ___ ____ _____ _____ _____ and
_____ _____ strong. _____ _____ _____ _____ _____ _____ with
_____ _____ and really _____ _____ Grenville.

He, meanwhile, was under a very different experience.
He walked _____ along the borders of the lake, and, re-
moved from her presence, the charm which _____ protect-
ed him ____. The bitterness of his _____ mood _____ in
him _____ _____ and aggravated by the sense that she
did not care _____ _____ He hardly dared to realize what was
going on within him; _____ tried _____ believe it was mere im-
patience to be _____ ___ again _____ but when the time came to go
back, he had something _____ begun to stir in his ___, though
_____ _____ recognized _____ like anger _____ hurt and
shrinking from this _____ _____ _____ _____ _____ to get
behind him; but it did ___ _____ dogged him like some
cowled figure, and kept _____ _____ _____ reproach and
dejection. He did his utmost _____ _____ ___ the _____
that had _____ taken him, and _____ _____ _____ cheerful-
ness, but he could not recover his spirits. They had arranged
to take the children for a walk, and _____ the shadows of the

forest, and he tried to hide his condition in his kindness and
his attention to them. For a time this succeeded; but at last
the truth was felt by her, as his replies when he spoke to her
were so short, and his smiles were so slow in coming. At last
she said to him with a certain constrained abruptness—

"I know why you are so moody. You are afraid you have
done me an injury, though you might perhaps have thought
of it a trifle sooner. But leave that matter to me. We
have quite enough each to do to bear our own responsibilities."

To his morbidly sensitive ear her voice seemed hard and
flippant. He hung his head and walked on in silence.

"Well," she said presently, "are you not going to speak to
me?"

He looked at her, and was wounded afresh by a smile that
seemed almost mocking.

"Perhaps," he said, "if what you tell me is true, I had
better go and bear my responsibility in solitude."

"If you like to," she answered, "certainly."

He stopped short in his walk, and fixed a long look on her.
Then he held out his hand, and quietly said, "Good-bye."

"Good-bye," she repeated, and turning away, moved on.
He remained where he was, leaning listlessly against a tree.
A swarm of torturing thoughts at once sprang at him out of
their ambush, accusing with hateful voices the woman whom
he had just been losing.

"You," they said to him, "are by no means her first lover.
You are not the first—and you have not even the first
place in her."

That these accusations stung him and like truths. It was
too much say wounded him, like the stings
of mosquitoes, with pain whilst it maddened
him. He looked after her to see if she were out of sight.
She was not. She was at some distance; but just as his eyes
turned to her, he too stopping, had turned his eyes towards
him—a glance which though still resentful seemed to be full
of melancholy. He hurried towards her as though she were
his life escaping him, which he must return to, though the
process were full of pain.

"Irma," he said, "forgive me. My soul will kill itself if I
leave you."

They walked on side by side, each of them still trembled.
At last she spoke.

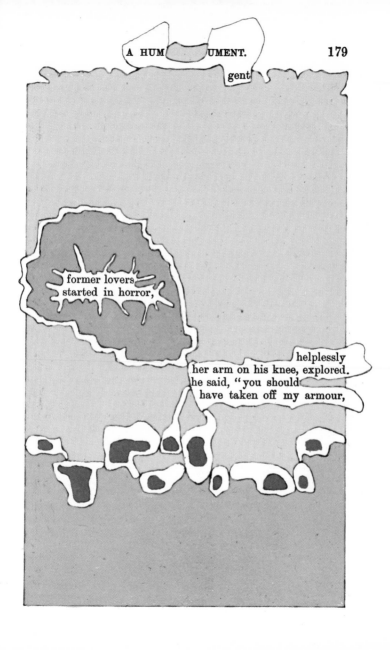

gent

former lovers
started in horror,

helplessly
her arm on his knee, explored.
he said, "you should
have taken off my armour,

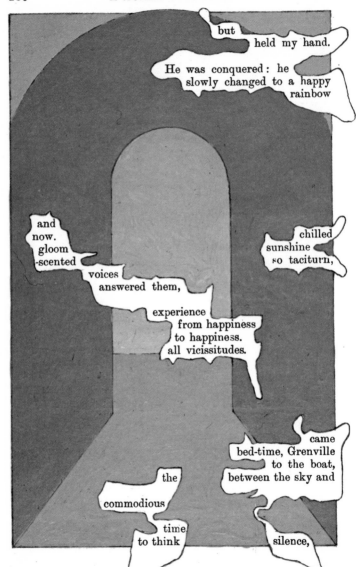

but

held my hand.

He was conquered: he
slowly changed to a happy
rainbow

and
now.
gloom
-scented

chilled
sunshine
so taciturn,

voices
answered them,

experience
from happiness
to happiness.
all vicissitudes.

came
bed-time, Grenville
to the boat,
between the sky and

the

commodious

time
to think

silence,

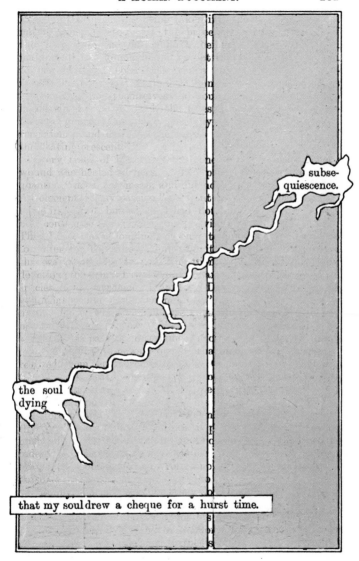

the soul
dying

subse-
quiescence.

that my soul drew a cheque for a hurst time.

and later on,

more than volumes of philosophy
serenity
became
his life.

without
outer incidents,

of reality or illusion.

intellect
was scattered,

guiding hand had been ever
the lonely sower

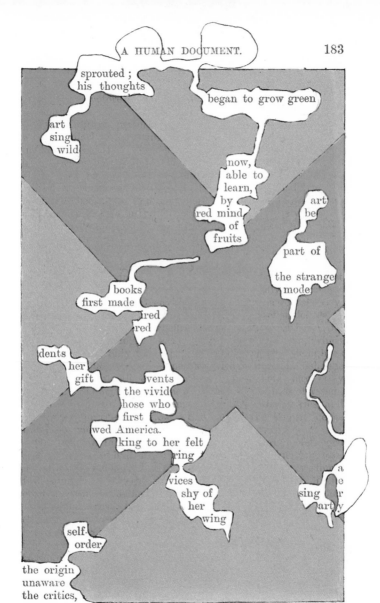

sprouted ;
his thoughts

began to grow green

art
sing
wild

now,
able to
learn,
by
red mind
of
fruits

art
be

part of

the strange
mode

books
first made

ired
red

dents

her
gift

vents
the vivid
hose who
first
wed America.
king to her felt
ring

vices
shy of
her
wing

a
e

sing r
art y

self-
order

the origin
unaware
the critics,

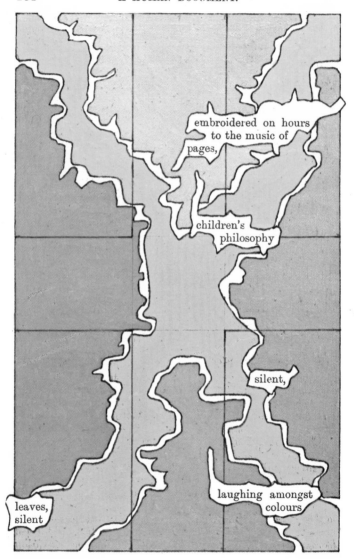

embroidered on hours
to the music of
pages,

children's
philosophy

silent,

leaves,
silent

laughing amongst
colours

is like a page out of an illuminated

lover

peculiarity
defensible, 'variety

question
thoughts.
doubts show

call it
utterly
itself,

Mrs. Schilizzi, without
question

Grenville,
At the same time

two lonely voyagers
lost their

conclusion,

they examined it and
cried in the dark,

Amplify your unhappy to-morrow

clairvoyance

to him
fixed
fixed

for me.

still as
an inverted
silence,
stars,

wonder
wonder,

condemn
that which
sealed

men

Not
by asking
what layer of
thoughts
breathed
ever breathed

go on; go on.

Look up; look up.
Come, be near me.

above us,
space, and
a ball of
milky light
—the book of
stars
vibrating

"Can it be
in my
Barren garden of life
that you
blossomed into this one wonderful
flower?"

CHAPTER XIX.

"What has happened?" he asked. "Is it illness? Is it anything serious?"

"No," she said, "only business. I remember something about it; and something has to be done, about which I have to be consulted, and—more important still—for which they require my signature."

She showed Grenville the letter, and explained what she understood of the case to him. In spite of the rude break which it would make in their present existence, he saw that for her own sake it was really well that she should go; and he pointed out to her what she had not at first realized—that the whole business could be settled within a week.

"Leave the children here," he said, "and ask the Princess to come to them; and before ten days are over you can easily be back again."

"And you," she said, "when will you do?"

"I will come to England also. Who knows but that my letters may also contain a summons? I had but six weeks of freedom, and four days already gone."

She started at these last words, and suddenly seemed scared. "Yes," she faltered, "yes; and what will you do then?"

His eyes dropped. He was silent, lost in perplexed thought. She made no further till from her hands, helplessly.

"We are both as it said no lost, if it we had been sailing in a boat of dreams, and now, now, with all that belong to it, is to be lost upon the rocks of reality."

Her speech roused Grenville. "Nonsense," he exclaimed with a vigour which approached roughness, but which brought her, for this very reason, a certain sober comfort. "If you and I are only realities to one another, we shall find that it is not our boat which is the dream, but the rocks, which you fear will wreck it. Come, you mustn't be downcast. Let me go to the lodge, and look at my own letters; and when I come back you shall see me in the character of a practical man."

There was every need, he found, for at once redeeming this promise. It is true that none of his letters was an absolute summons to return; but there were amongst them two important communications which made him see that his instant return would be desirable. One was from his man of business, the other from the Chancellor of the Exchequer. Both of them were serious enough in themselves, but quite apart from the actual news contained in them, they brought him

tion to face with a number of practical problems which he had known would one day ask for a new solution, but which had till this moment seemed more or less vague and distant. All of a sudden they became close and tangible, and pressed on him as it were, with their importunate and painful details.

Returning to Mrs. he discussed their immediate movements. A messenger was despatched to Lichtenberg, who would go from thence to the Princess, taking a letter to her, and returning that night with an answer; and so soon as arrangements could be made for the proper care of the children, Mrs. Schilizzi would start by way of Vienna, for England. At first it was assumed that Granville would travel with her; but suddenly, with a doubtful smile, she said to him—

"Do you think you ought to? Perhaps I am foolishly nervous. I know she would so little, and I never before had occasion to be nervous at all. You must say what is best for me. I trust everything to you."

"Irma," he answered earnestly, "I need hardly tell you, for you already are sure enough of it, that except for external circumstances, I would never quit your side. But in this case perhaps it may be best that we go separately—for part of the way at least. Let me think it over by myself, as I put my own things in order. My own things!" he repeated as he prepared to go back to the lodge. "How wretched to think that my things are for a moment separate from yours!"

As soon as he was alone he set himself to consider the situation. With regard to the journey, he judged it best on the whole that he should precede her to Vienna, where he would meet her and her maid, and go from thence in the Orient Express to Paris with them. In this way he would avoid meeting the Princess, who, before she had reached Vienna, and heard nothing of his movements; and who, if she arrived promptly, as she might very possibly do, would be startled to find—"But wherever was it"—rose at once to her mind.

"How much happier"— the thought came like a cloud—"how much happier life would be were there nothing in it that required concealing! this very up till now, would have been welcome to find out how to hide. And yet," he continued, "we all of us have our burdens. Let me make the best of this one by the way in which I accept its pain."

Then with a sigh he let these reflections pass, nor to leave

him—he knew that well—but to take up their lodgings as guests in some dim chamber of his mind; and others succeeded them, in certain respects more formidable, but yet of a kind which he faced with a better heart. The latter, but not the former, he recorded carefully in his diary.

"At last," he wrote, "the test, which I have so often invoked, is going to be applied to me; and I shall be taught by experience whether all this is inspiration or madness, and what sort of stuff I myself am made of. I have often reflected—not with reference to myself, but merely as a general truth—that a man of imaginative temperament buys his moral furniture cheap. He may decorate his mind, as if it were a spiritual palace, with visions of the loftiest feelings, the tenderest sympathies, the purest principles and acts of complete self-sacrifice; and connecting himself with these by a certain imaginative process, just as he might connect himself with a character in a poem or novel, he may seem to himself to be a fine and sublime person, when he is in reality selfish, and mean and heartless.

"And now this comes as a question which I—I, Robert Grenville—must answer. Am I myself a person of this kind? Most worthy Judge Eternal—I cannot think except by supposing myself before some such judge—if this be so, to what a depth I must have sunk! For nothing can justify me in my present condition and situation but the fact that I am what I think I am—that I mean my feelings, and shall be true to them not in imagination, but in reality. Do I mean them? Now comes the time for testing whether I do. And I welcome the test. I am impatient to be applying it, like a man who hits himself to make sure that he is awake. It's no good my hitting myself, or I might do so at this moment; but I shouldn't be a truer lover because I gave myself a black eye. How can I laugh? I am not laughing really. Let me just state it over again—my whole case as it stands.

"Suddenly, during the last three weeks, that strange catastrophe has befallen me, which when happening in the sphere of religion is commonly called *conversion*. A something which I had always considered as something of secondary value has bewildered me by showing itself as the one treasure in life; and for the sake of securing this—so I have told my soul—I have already sacrificed much, and am prepared to sacrifice everything. But what I have sacrificed thus far has

scruples

scruples

Again and again

my truth,

my life

scruples

my thought my words

My lucky moment

my home,

no dream,

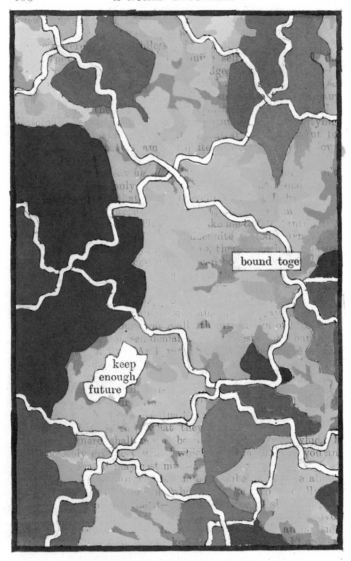

There will be difficulties everywhere.

ALL,

ÆSTHETICS.
CIVIL WAR.

MILLBANK:

IDLE HOURS

Blatherwick (C.).

toge

inspect the landscape

ART IN THE MODERN STATE.
With Facsimile. Demy 8vo, 9s.

good-bye.

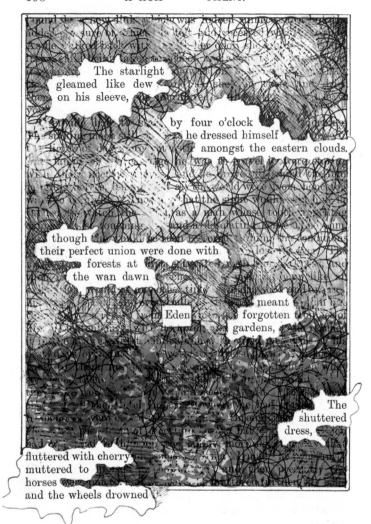

The starlight
gleamed like dew
on his sleeve,

by four o'clock
he dressed himself
amongst the eastern clouds.

though
their perfect union were done with
forests at
the wan dawn

Eden meant
forgotten
gardens,

The
shuttered
dress,

fluttered with cherry
muttered to
horses
and the wheels drowned

CHAPTER XX.

such a new and expanded

range to

hid in a field

about three in the afternoon,

art

under

the Austrian

of yesterday,

made it

art

without losing

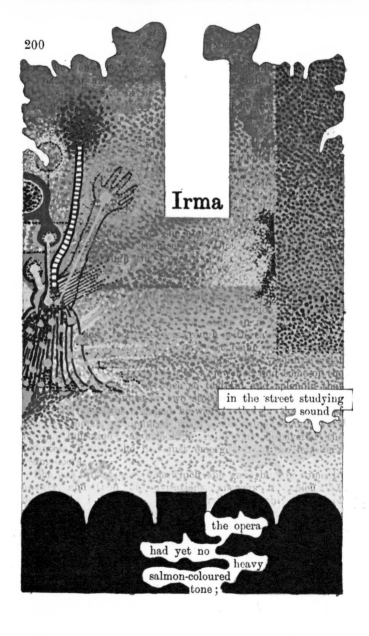

Irma

in the street studying
sound

the opera

had yet no

heavy

salmon-coloured

tone ;

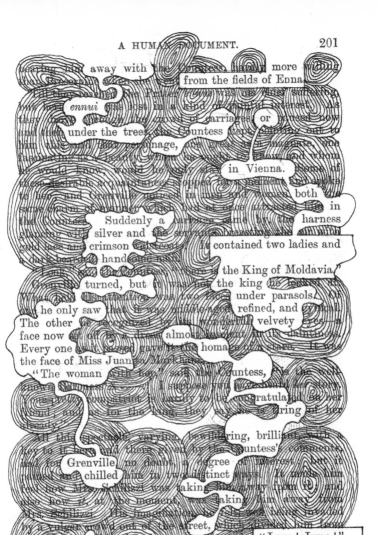

away with

from the fields of Enna.

ennui

or

under the tree

in Vienna.

in harness

Suddenly a
silver and
crimson hand

contained two ladies and

the King of Moldávia,

the king

he only saw that it was

under parasols,
refined, and

The other

velvety

face now

Every one

the face of Miss Juan

"The woman

the Countess,

ring of her

Grenville
chilled

mundane

murmur

"Irma! Irma!"
under his breath,

of dust from his waistcoat.

At last his trial was over. The Countess dropped him at his hotel. The moment the porter saw him he put into his hand a letter. Greuville received it eagerly, fancying it might be from Mrs. Schilizzi. It was not. It was from the Ambassadress, who had somehow heard of his arrival. She begged him to come that night to dinner; there would be no party. He despatched an acceptance, resigned rather than pleased; and indeed, when the time came he was little less than miserable. His host and hostess talked to him so much of his prospects, and he could not explain that they were now his prospects no longer. He was conscious of their wishes for his success; but their very wishes irritated him. He felt as jealous of any influence that would draw him from Mrs. Schilizzi as he could feel along that would draw her from him. A strange sensation was dawning on him that his affection for her was, except for herself, making him alone in life—a pariah amongst those who had hitherto formed the world for him. He was not afraid of the situation. It only made him feel how entirely he depended upon her. Wearied with the fatigues of the day, he returned to his hotel early, and was just preparing to close his eyes, and so to abridge the hours which still separated him from her, when the thought suddenly struck him that it might be a help and a pleasure to her if he went to the station and met her on her arrival. To rouse himself now was really a matter of effort; his eyelids were so heavy he could hardly keep them apart. But rouse himself he did, and redressed himself, and driving to the station, he awaited her. As the train came drifting in, he half feared that something would have detained her, and his heart gratuitously embittered itself with a pang of anticipated disappointment. Amongst the dim figures that emerged he soon detected her, and hastened to her, glowing with sudden happiness. With a start of surprise and pleasure, she gave him her hand and looked at him, but the moment after the pleasure gave place to nervousness, and her voice hardening and acquiring a note of petulance, "You shouldn't have come," she said. "Please go away and leave me."

"Can I do," he said, "nothing for you? May not I get you a carriage?"

"No, no," she said, almost turning her back on him. "Good-night; you can call at twelve to-morrow." The next moment he saw her hasten towards a man—a tall, corpulent man—

whose hands glistened with rings, and who, with the aid of his nose, suggested finance and Israel. With her hand on the sleeve of this gentleman's furred overcoat, she quickly disappeared in the direction of the cabs and omnibuses.

Grenville returned to the bed in which he had been about to rest himself, full of a bewildered bitterness which made rest impossible. He could not banish her strange reception of him from his memory. Her voice through the watches of the night kept ringing and echoing in his ears, and hour by hour its tone became harder and more bitter, till her image at last appeared to him, as he lay there half dreaming, like that of a woman who had suddenly grown to hate him, and having ruined his life was going now to spurn him away from her. The misery of this experience was increased by its entire unexpectedness. It staggered him. The elements of his life appeared to him in some new combination like a kaleidoscope shaken by the Furies.

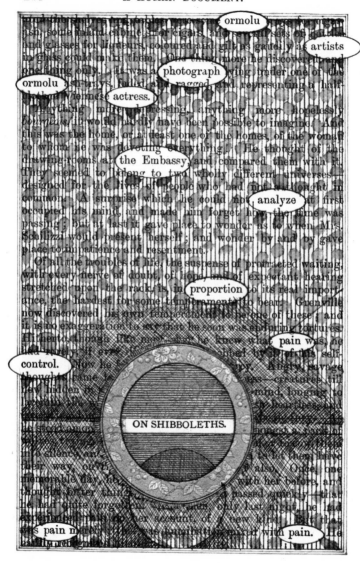

ash, some inlaid cabinets of cigars, and little sets of bottles and glasses for liqueurs, coloured and gilt as gaudily as artists in glass could make them. One thing more he discovered, and one thing only. It was a photograph lying under one of the ormolu ash-trays, faded and ragged, and representing a half-length of a Viennese actress.

Anything more depressing, anything more hopelessly bourgeois, it would hardly have been possible to imagine. And this was the home, or at least one of the homes, of the woman to whom he was devoting everything! He thought of the drawing-rooms at the Embassy, and compared them with it. They seemed to belong to two wholly different universes—designed for the lives of people who had not a thought in common. A surprise which he could not analyze at first occupied his mind, and made him forget how the time was passing; but at last it gave place to wonder as to when Mrs. Schilizzi would present herself; and wonder by and by gave place to impatience and resentment.

Of all the troubles of life, the suspense of protracted waiting, with every nerve of doubt, of hope and of expectant hearing stretched upon the rack, is, in proportion to its real importance, the hardest for some temperaments to bear. Grenville now discovered his own temperament to be one of these; and it is no exaggeration to say that he soon was enduring tortures. He never, though he now knew what pain was, he had been, if ever, robbed of the power by it of his self-control. Now he thought of his misery. Angry savage thoughts rose in him, savage as those of creatures till lately hidden in his own mind, longing to

ON SHIBBOLETHS.

their way, on a memorable day, before, and thought it rather longer, passed quickly than he had here once last night, he had experienced not so keen a mount of new. His life was pain merely that it was filled with pain. He

At last—
he

kept on the rack for
distant
hearing.

held his breath;

fashioning

a

passionate
note

—for

twenty minutes,

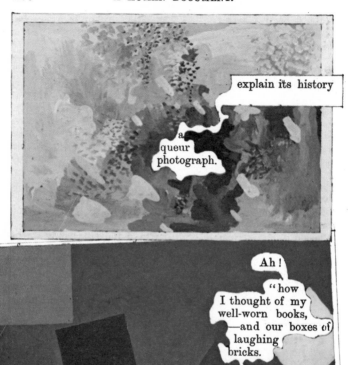

explain its history

a queur photograph.

Ah !

"how I thought of my well-worn books, —and our boxes of laughing bricks.

assembled, and hoping

As for the photograph, [...]

[...] to live another single with the squalid dimensions [...]

Mrs. Schilizzi was to beer... saying that
mother... —a lady whose... well
and... in the virtue that comes
...it, ...despatches...
admitted, to act... As his... towards
guardian angel. Her zeal... kept saying...
which a well-worn... He had his
...ted of con... becoming dizzy...

He saw her as he turned how heavy his hand would feel
...wd, which at last hirff for ever f... the
...nt between them laden so he felt—a naked
... reached Ld the dirty passage
... an hour or f all this grew deeper;
... hed and... wait,
... the world... om chairs
around...

Even... realize what t... himself in these
stages he might ex... which of them...
swing or had... his...
Or... precisely Easter... self...
... not because he... the details of
precisely opposite. ... should
...ould he have so arranged it his des... she...
... hour come when I asked himself, w...
... ...eart to I hesitate...
and... while... admi... I forgot... A...
...t with... only but... must now write to Lord
... ... of his whole futur that... shall never...
instant ag... and growing st... why not because...
...ought o... over, wandered in... because...
Everything had an air of beillest reason. Sheets

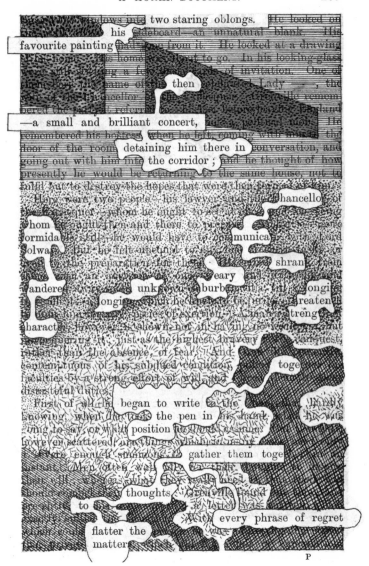

two staring oblongs.

favourite painting

then

—a small and brilliant concert,

detaining him there in

the corridor;

eary

toge

began to write

gather them toge

thoughts

every phrase of regret

flatter the matter

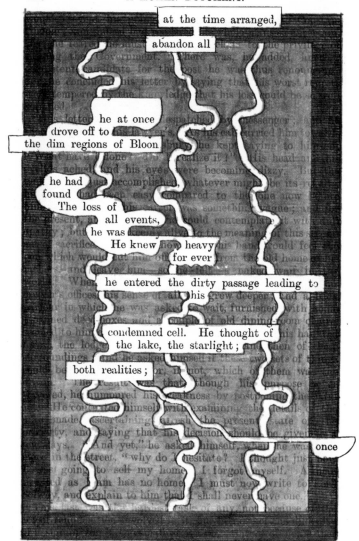

at the time arranged,

abandon all

he at once
drove off to
the dim regions of Bloon

he had
found

The loss of
all events,
he was
He knew how heavy
for ever

he entered the dirty passage leading to

condemned cell. He thought of
the lake, the starlight;

both realities;

once

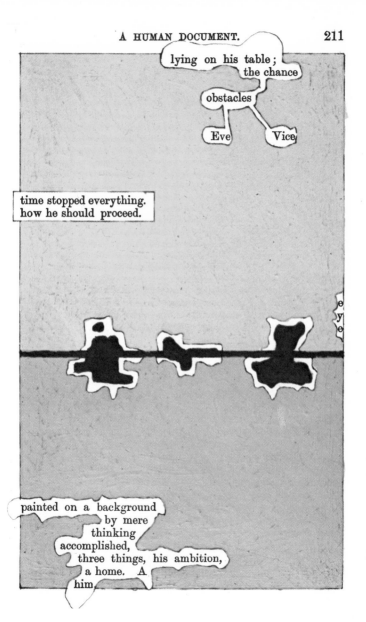

lying on his table;
the chance

obstacles

Eve Vice

time stopped everything.
how he should proceed.

e
y
e

painted on a background
by mere
thinking
accomplished,
three things, his ambition,
a home. A
him

lay in

a large envelope

a ... house of

flattering words,

top ; and

bottom.

welcome benignity

a sort of hollow letter. It contained

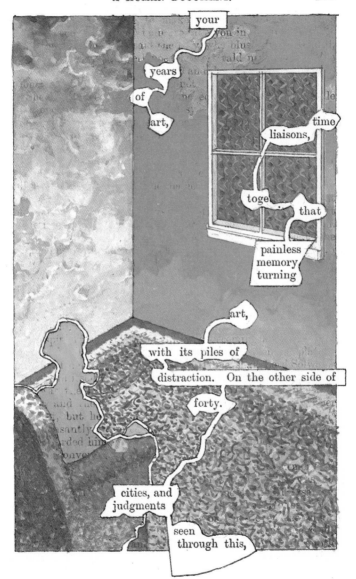

your

years

of

art,

liaisons, time

toge that

painless
memory
turning

art,

with its piles of

distraction. On the other side of

forty.

cities, and
judgments

seen
through this,

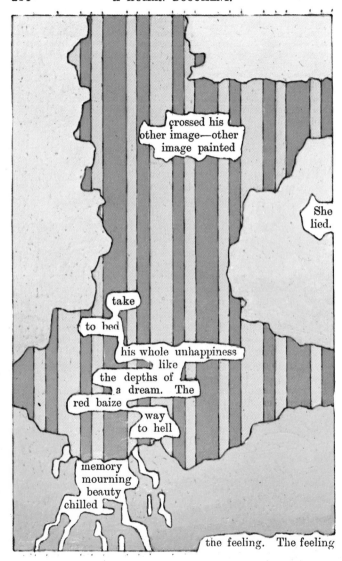

crossed his
other image—other
image painted

She
lied.

take
to bed
his whole unhappiness
like
the depths of
a dream. The
red baize
way
to hell

memory
mourning
beauty
chilled

the feeling. The feeling

... not at his command, but the manner ... look proper to it, from the ... of habit ... his ... and produced themselves; and any one who ... would have thought on two or three occasions that he had ... happy victim to ... that were then detaining him. Several observers indeed did think so; but ... observer could have known that at the very moment when appearances seemed most to warrant such conclusion the name of an absent woman ... still secretly on ... and that the touch of a hand not hers on his arm as he went to ... nerve ... a shudder as if it had been ...

Thus drew ... its close ... **pollution** ... as a sombre, and then turned to ... **day in London.** and when at last ... to be ... It ended with a hope of a certain lett... **next morning,** ... hope so intense that it defeated ... and made sick by doubt ...

CHAPTER XXII.

... few letters were brought to his bedside ... of two he held them in his hands, keeping them ... closed, and ... daring to look at them, he was so perversely afraid of ... that **morning came,** there was none from her. However ... a hasty scrawl; its wording was **curt and almost careless;** ... it begged him to call on her ... have told my mother-in-law, it continued, that ... Lichtenbourg and its neighbourhood; and she is pleased to consider that as a sufficient explanation of your existence.

In one way he was delighted. He would be with her sooner than he had expected ... night promised his host to ... **twelve in Downing Street;** and there was some awkwardness ... **so** ... an engagement. Pos... a messenger with a letter ... **full of excuses** ... were not perhaps very accurate ... the messenger ... hardly been gone for half an hour when a telegram reached him from her, begging him to come at four. Here was a double annoyance

fused sense

blew through his mind

turbe
he could hardly breathe.

bulated figures,
with feathers,

lying on his chest and smothering him.
about

to tear in pieces
and open
an intolerable anal

secret

QUANTITATIVE ANALYSIS (INTRODUCTORY LESSONS ON).

flower-beds.

the misery of
windows

paper flowers in the fire-place,

some large,
large
ladies
edged in black, of tombs.

-men.

for every Day in the Year; and under this
newspaper

some
opaque
British ideas

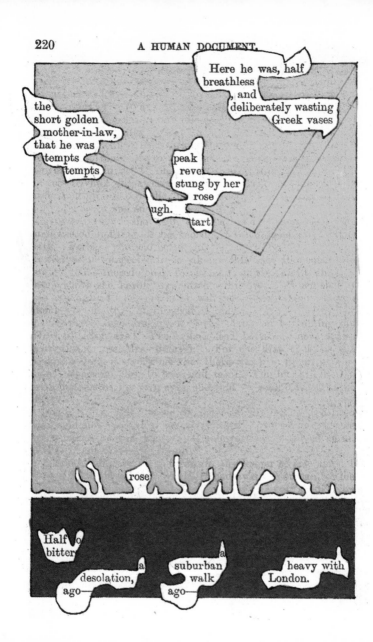

Here he was, half breathless
, and
deliberately wasting Greek vases

the short golden mother-in-law, that he was tempts tempts

peak reve stung by her rose

ugh.

tart.

rose

Half o bitter
desolation,
ago——

a suburban walk
ago——

heavy with London.

and now,
the
promised letter arrived,

There was
toge
under the circumstances,

the
tender
circumstances,

personal

with regard to
and with regard to

mind

affairs

give
no particulars eve

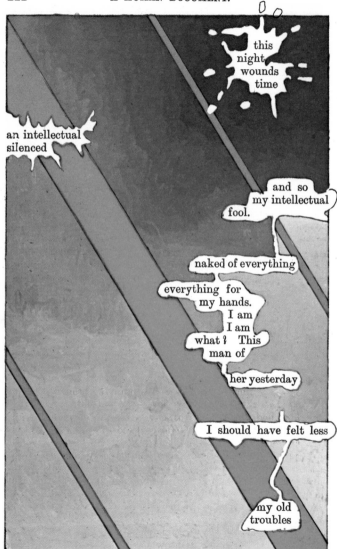

may suffer seems to be absolutely nothing to her, except in so far as I annoy her by letting her see my suffering. How can a woman be like that? I don't know. It's all a puzzle to me. Irma, Irma—are you going to make me hate you? If you could I should be free, and there would be an end of the matter. But I can't hate you; that's the difficulty. I curse and anathematise my folly, but still sticks to me, though it gives me no longer... and... for you put in your head the reasons with which you would... me. If I didn't love you, you might... hard, and shall... as you pleased. As... time I can plead for you, ... and make out a case for... your strength before me, and showing still ... you then the... is the difficulty thing) the... that I refute all my... feelings and repeat to myself... I can't write down what... Irma, I won't even think of it. I will believe, though I can hardly realize, that you are still the Irma of that... lake and forest, who was not ashamed to tell me all her thoughts, or to show me her eyes with tears in them. Yes, I will believe that, even if I cannot feel it.

But quite apart from all doubts of this kind, how wretched my position seems... I have given up everything for the company... condition... that results... for a quarter... this hour... and these twenty-four followed by hours of ... hours... as if all the time ... stretched and ... on a rack. And yet—and yet—... contemptible or... from Irma, I should be... saying this to you; you are worth anything to me; you are worth everything."

After he had written this, he read it over again... at one sentence repeating it half aloud to himself... he said, "it is just that. All my time is being... tortured on a rack... until ... am still more wretched afterwards.

Seven days went by, and neither... grew... the strain on his nerves became even more intolerable. Each time he met her she would, once or twice at least, look at him with her old expression, and speak to him with her old temper... but always in the background there seemed to be some ambushed anger, which would spring out at him suddenly and

knew not for what reason; and, worse still than this, when her anger was hushed or absent, and when her eyes were kind, she had an air of preoccupation which he had never noticed in her before; and when her words replied to him, her thoughts seemed to be wandering. At each successive meeting, from its beginning to its close, he was hoping every moment that she would break through this strange disguise, and show him her true self again—the self he had once known. But he hoped in vain; and even when she said Good-bye, something rigid remained in the lines of her softening lips.

Painful and perplexing as these interviews were in themselves, their pain was doubled in the memories which they left behind them, and which permeated the hours he was away from her like the virus from some snake's bite. And these hours now formed the great bulk of his life. Some of them were occupied by his own business matters; some by work in Downing Street; and for each night he had some dinner or party. But _____ and engagements left him long intervals _____ he had not the heart himself to seek out any _____ indeed, even had he wished to do so, he would generally have been unable; for she left him in such uncertainty as to where and when she would see him, that he rarely could make an engagement four hours in advance. He was always returning to his rooms to see if there were any letter from her; and then, when there was one, which settled their next interview, he vainly tried during the interval to calm himself by walking, wandering away _____ or into obscure streets; whilst life was for him like a _____ of iron in hell, and his thoughts were like birds w_____ twig burn them.

"I used," he wrote in his diary on one of those unhappy days, "I used to think, before all this happened, that I had plenty of self-control; but I don't know now what's come to me. Certain words from her, even little looks and gestures, wound me and make me beside myself. My wretchedness now is like the acute wretchedness of a child. All these _____ goriness of the _____ of the damned, or some mad _____ how got up to mock me. Through conversation, through music, _____ I feel the desolation to which she _____ and then—I can't help it—I get embittered against her. Sometimes when that happens I am aghast at my own temper, and I wonder if any one ever had

violent little acts

Once when I caught myself cursing Irma, near Wimbledon—

a penny

spent

The day after Irma

I paid some money

at her banker's.

for

philosophy at a shop,

boys and a policeman all began to stare

Don't you know I've no time to spare?"

Hampstead
it was

He politely
gave the man
his heel,

ted

the same brown
expedition

folds like a

Heath
dread

mother-in-law

Do be careful.

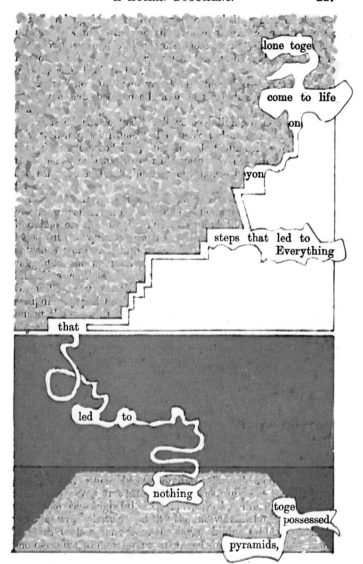

lone toge

come to life

on

yon

steps that led to
Everything

that

led to

nothing

toge
possessed

pyramids,

the carpet, rich in style but monstrous in design and
colour, whose crude vulgarity made a staring round for
everything.

Grenville tried to keep his impression of the room to
himself, and merely said, "What a fine collection you have
here!"

"Paul," she replied, "says that there isn't a picture that
wouldn't fetch anywhere double more than the price he paid
for it. Come—I will show you his room."

This was full of floridly carved painted furniture, much
resembling that of a carriage at a station; and the whole
was somewhat suggestive of the upholstery of a Pullman car.
On the third apartment with electroplated articles. There
were some shelves designed for books, and also boxes of
cigars; and art was represented by coloured prints of
racehorses.

"You won't," said Mrs. Schlizzi, "find the portrait of
any actress here. Paul's afraid of his mother, whose eyes
are as quick as arrows. She tolerates those here so only under
severe protest; and she takes him to church with her every
Sunday twice. Oddly enough, in England he thinks she is
quite right; and for this reason he prefers living abroad."

"What a home," thought Grenville, "for such a woman as
this! It bore the same relation to the home with which
his own fancy had associated her.

Here
comes
delicate
old-fashioned flower
bound,
 love

We can be
can be myself again.

home with pain. And yet compared with
this house, I look ... on it ... large
here—away from this dreadful
this carpet, how ... and shabby ... and
room at home ... was in such a
... I ... to keep ... these old things
of mine ...

He began ... looked at her **drawing-
worn**
her **miniatures** ... the room with him, standing
by him and **explaining** ... the **volumes she**
had valued ... **a child,** ... **blots and pictures** she
had made ... **on margins and** ... pointed
him her ... **miniature** ... her father ... **and all**
... brooded ... **over her childhood**
... the **wings** ... both of them and **fold them**

... "Irma," ... could keep you always ...
She ... no ... ing as it ... a sudden
thought. "Wait a minute," ... turned ... toward
... "Do you remember ... Vienna that I
would show you something? ... couldn't and ... she
you forgot to ask me about it ... what will do us well
"This is Paul's **photograph.**"
... took it. He stared ... features were not
... ... They were those ... who had been his
... ... the train. carefully ... made
himself ... sure ... and ... which at the moment he
had not time to analyze. It was as if some unknown weight
had been **lifted from his heart,** ... had been lightened ... he
... turned away from him when he took it, ... nothing
... expression. His first impulse had been to tell her of
... recognition ... but he ... stopped himself, and he returned the
picture to her, saying merely, "One day I must tell you
something."

She looked at him ... without asking his meaning.
"It is late," she said. "It is time for me to be going
... you must leave me ... You must on no account walk back
with me."
"Tell me," he replied, "when shall I see you to-morrow?"
"Ah," she exclaimed, "I wanted to talk to you about
... To-morrow I am quite free ... Mrs. Budden is going into
the country ; but the day after, I am going into the country

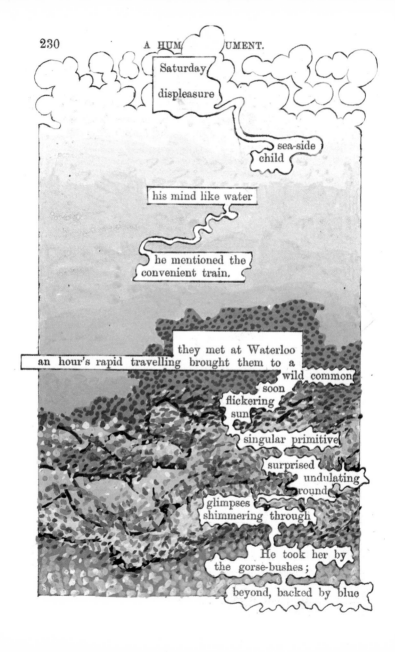

Saturday

displeasure

sea-side
child

his mind like water

he mentioned the
convenient train.

they met at Waterloo
an hour's rapid travelling brought them to a
wild common
soon
flickering
sun
singular primitive
surprised
undulating
round
glimpses
shimmering through
He took her by
the gorse-bushes;
beyond, backed by blue

to
ge

and
love.

admit
them

sufficient,
together up the avenue.
a certain
dilapidation
she
ill-mended,
he
just
by rust
down-drawn

chest

matting
pungent with

appreciation

magnificent
long gallery
boots

with
smell of
revelation ;

my moth

dead.

My moth

that quivered

I remember
the corners

the
closed mouth

blind

coming.
His face
the wall
his lip,
his eyes

pointed

Come,
my moth

rain

London.

Poetry and prose
on
London,

Signs and

silence

Vauxhall

laughed

Liverpool Street,

illuminated

gliding
London behind

the anxieties

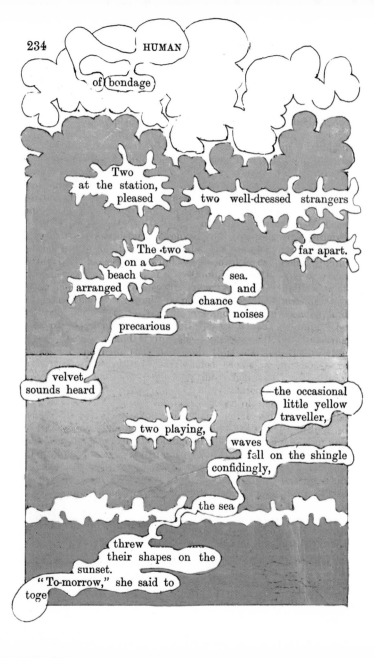

of bondage

Two
at the station,
pleased

two well-dressed strangers

far apart.

The two
on a
beach
arranged

sea.
and
chance
noises

precarious

velvet
sounds heard

—the occasional
little yellow
traveller,

two playing,

waves
fell on the shingle
confidingly,

the sea

threw
their shapes on the
sunset.
"To-morrow," she said to
toge

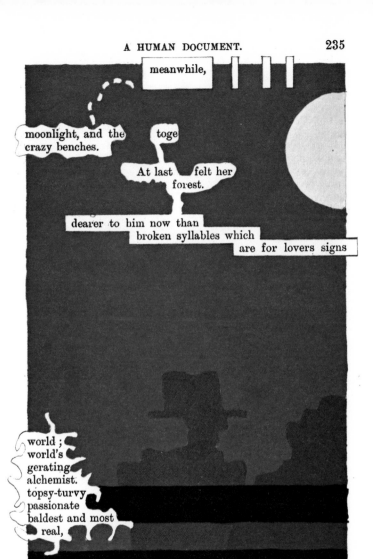

meanwhile,

moonlight, and the
crazy benches.

toge

At last felt her
forest.

dearer to him now than
broken syllables which
are for lovers signs

world ;
world's
gerating
alchemist.
topsy-turvy
passionate
baldest and most
real,

lamp is always burning in your honour, and where sometimes in your honour there is nothing but solemn silence, sometimes the murmur of some new act of devotion. Tell me, do my words reach you so as to make you feel them; or are they like a jet of water from a fire-engine too far off, which breaks into spray before it strikes what it is aimed at?"

"Don't," she exclaimed, "don't. Your words not only strike, but penetrate; and my heart is so full of what they mean and so jealous of losing it, that—what shall I say? Dear, I can hardly bear it. I am rather sad to-night. I will tell you why to-morrow."

To-morrow came; but the promise was not at once fulfilled. In the morning she was sad no longer. She was buoyed up on the tide of a triumphant happiness against which she could not struggle; and the horizon of the day before her was like that of a summer sea, which met heaven and hid all the world beyond. Some hours she devoted to her little niece, doing for her all that could be done by the kindest mother; but every minute not thus occupied she spent with Grenville, full of a simple-hearted happiness which trouble dared not sully. But towards the evening her sadness returned again. They were sitting on the beach, watching some distant sails. Suddenly she said to him "To-day you've been very good to me. You've not been angry with me because I've given so many hours to my niece; and yet I am sure it tried you. But you knew it was my duty; and you never once looked cross at me. I am so touched, dear, by all these little forbearances. And yet—oh, Bobby, Bobby, there is something I want to say to you. I wanted to say it last night, only I hardly knew how; and all to-day I've not wanted to say it at all."

"What is it?" he asked. She hesitated and blushed. She began to speak, and then stopped herself. What was in her mind Grenville could not conjecture; but one thing came better to his view than ever it had done before—the fact that for him she was guilelessly and defencelessly truthful. There was something almost painful in the degree to which this touched him—in the new and sudden call which it made on his care and tenderness. "What is it?" he asked again. "Tell me. I shall understand, whatever it is."

"Yes," she said, "I indeed believe you will. You understand me too well; and it—you are too good to me. I think I can tell you now. You see, Bobby, my loving you—you see

"Yes?" she gasped. "Is it anything very dreadful?"

"You remember," he answered, "that at your house the ~~other day you~~ showed me a certain photograph. ~~Well—I~~ recognized it. I have already met the original. I travelled with him from Paris to Vienna before my visit to the Princess. I talked to him. Listen, I will explain to you all about it."

~~"Are you sure it was he?" she inter~~posed. ~~"Was he alone?~~ I believe he very rarely is."

"He was alone in the train; but somebody was with him on the platform. He told me who she was. He was very ~~frank and communicative. You,~~ I dare say, ~~will know what~~ I mean by that. I don't want to dwell on it, but I want to tell you that since I made this discovery, the chief uneasiness that lurked in my mind is gone. I only knew it was there by the relief it has given me by going. I am appropriating nothing that he either understands or values. I always felt that this was so; but only now has it been proved to me. Can't you see with me what a difference this must make?"

She looked him long in the face; and at last, turning away, ~~"I am glad," she said,~~ "of ~~this. It makes me also happier.~~ You now see what my position is, and how completely, except for you, I am alone. Please don't fret about me. My heart has been lightened as yours has been. I am happy. I am alone no longer."

~~Nor next day was~~ the ~~state of her mind changed. The~~ thought that this peaceful interval would so soon come to an end did, indeed, sadden both of them; but it was a sadness brooding over peace, like clouds over a quiet sea. The mid day post, however, brought her a letter from London, bearing many stamps on it, and darkened with re-directions. "It is something from Paull" she exclaimed. Her cheeks flushed as she read it. "His work at Smyrna is nearly done," she said presently, "and—what is this? There are some new waterworks at Bucharest, ~~for which the firm has a contract.~~ He will be going there in three weeks. He supposes that I and the children are at Vienna or with the Princess; and as soon as he is able to do so, he will come to us."

She dropped the letter on her lap, and looked at Grenville silently. "Of course," she said at last, "it must have happened sooner or later; but sometimes, Bobby, sometimes one forgets things."

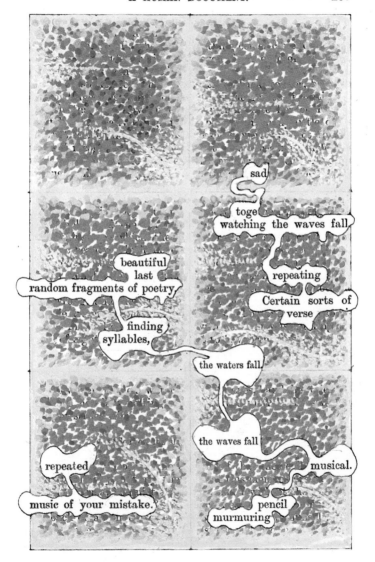

sad

toge
watching the waves fall

beautiful
last
random fragments of poetry,

repeating

Certain sorts of
verse

finding
syllables,

the waters fall

the waves fall

repeated

musical.

music of your mistake.

pencil
murmuring

See,

See,
See,
the things
the things

from the changed sea.

no future.
furniture

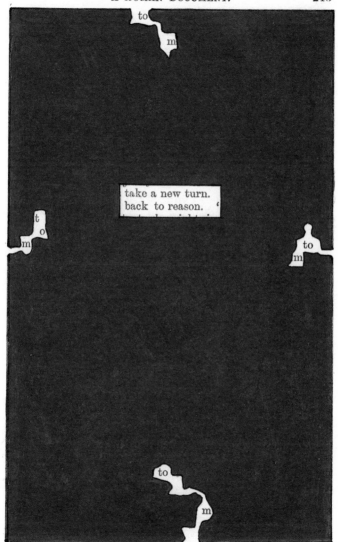

take a new turn.
back to reason.

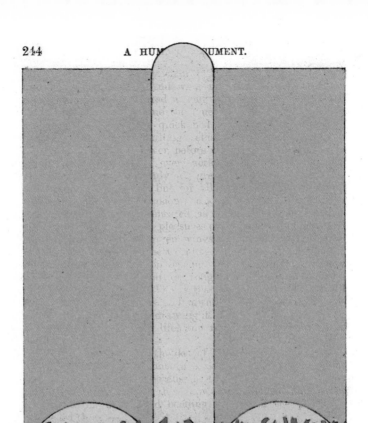

the beauty of
a living

ceaseless sliding

the
huge cylinder

look
and see
the measured
rise and
returning

tower
burnished piston
—rising and falling,
fully
the perfect skill of man.

wonderful,
wonderful

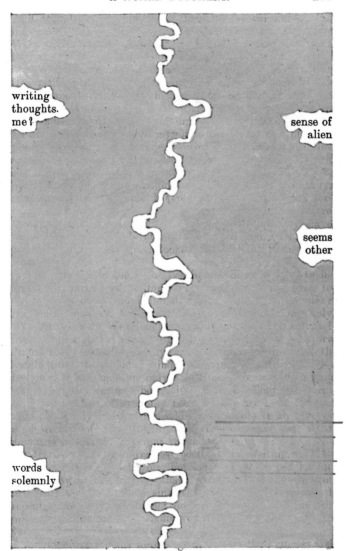

writing
thoughts.
me?

sense of
alien

seems
other

words
solemnly

bring the children back again even on the second, train.

what to call it—I am beginning to see that the same thing holds good. Some of the most pitiable are those that would be least pitied. I think this week I have been almost mad sometimes, and even now my temper gets into my pen, and I talk of the devil before I know what I am doing. I am a fool —a fool; and yet I am not a coward, for to all the world I have shown an unruffled front. But a fool I must be; for what is the cause of my wretchedness? Merely that a woman in ten days has written only three times to me, and one of these times only three careless lines. What a trifling calamity that sounds to one who reads of it! but to me who feel it— what has it meant to me? Here is a man who says that I am renouncing everything. I am remaining in London for no other reason than to complete the death of my ambition, and the act that will make my name. Meanwhile, almost every hour of the day her image has haunted me. Every thought I have thought, I have mentally brought to her, as some Catholic votarist lays flowers upon an altar. The one occupation that has given me any real comfort has been to write to her. All my hours of exertion have been like steps to the hour which was dedicated to this writing. And each day all my hopes naturally were to hear from her. I have been accustomed to reason with myself from my own experience; and knowing how to write to her is for me a daily necessity— how every day I am straitened till this is accomplished, I could not but conclude that unless her affection were decreasing, to write to me would be an equal necessity for her.

"Two of her letters have been almost worse than none— evidences of carelessness far more than of care. I was patient at first, though disappointed; but at last the gathering pain burst out in my mind like a fountain of bitter water. Much as I long to be honest, I cannot for very shame's sake commit to paper all the things I have said about her; and I cannot, for another reason—because no words could express it— commit to paper the misery in which I said them. But the kind of judgment which, in these moods, I have passed upon her, I can describe in general terms. Just as her connection with myself has been ennobled and sanctified in my eyes by my believing it, as I have done, to be the result of a serious passion, so in some moment, I was tempted to consider that passion not even strong enough to have the semblance of caprice,

unself

conduct

record one

render
soli

such a strange

concert,

As for me—as for my real self—I was ash

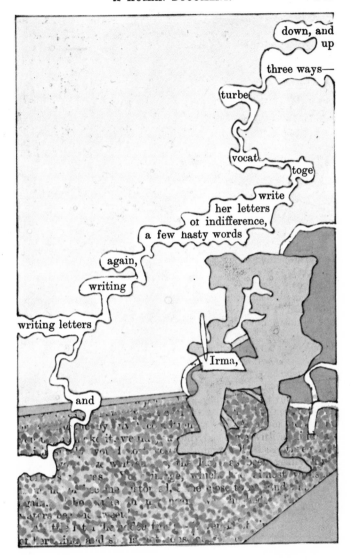

down, and
up

three ways—

turbe

vocat

toge

write
her letters
ot indifference,
a few hasty words

again,

writing

writing letters

Irma,

and

merely
think
art

I am coming to
that judgment

I shall be
The fatal
signature;
"

as

the dusty
evening shone through his mind
his doubts

connect

at last

he wrote in his diary,

only

oddly

connect

x
l
i
i

connect

The stranger knew all of them

royal personages diplomats,
stars of society.
our own ambassador at Vienna.

Lady Ashford

the Pasha

whose balls looked like
four milk-white horses.

all was
to go to a neighbour
even
my luggage, and that
small bag containing
my back,

down-pour
dismay

its time
to grow bewildered,

the clipped
clock
blinking

I entered
a great bowl
at first.
light broke from her.
for years; her voice
looked strange.

Have you
felt that this was
likely to reach
a noiseless moment,
no
no
put off
this moment

determined to reach

art

music

something
will be repaid in
a great
to-morrow.

assurance

I shall

attend
to

I can bear

Let us try toge

art

to-morrow
to-morrow

to-morrow, and to-morrow,
uninterrupted

art

ugh

ugh

in spite of

the gardens

sadness
remembered and

some

gardens
had tears in them.

in the words of Byron, "

"

" he said,
I come
naturally
by halves.
I even try to sway

she said, "go on. Tell me."

coming unhappy
unhappiness

toge

come back
evaporated
chess

is
book
game ?"

o philosopher

and

in the gardens,

this slight incident.

king yesterday.

J

and I

I think

and I think I

I think that

I feel that

—I wonder if you

you

She shook her head

what I feel

conceal

from

all

all

Paul,

having to live with

Irma. what can I say?
ring :

Do you know, ring the last
ring

Licht
See !

Do you know,

a wood
of light at the end."

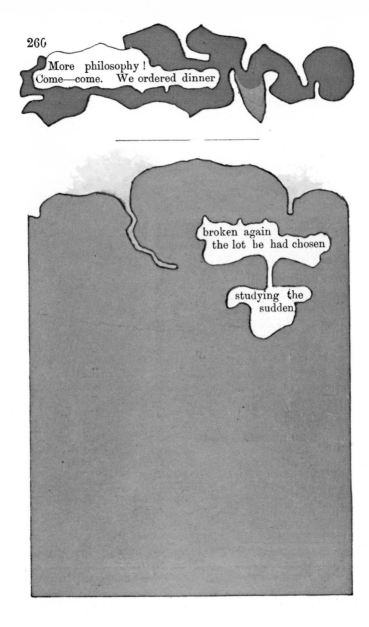

More philosophy !
Come—come. We ordered dinner

broken again
the lot he had chosen

studying the
sudden

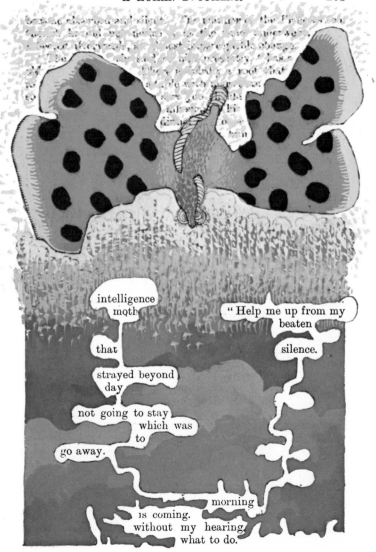

intelligence
moth

that

strayed beyond
day

not going to stay
which was
to

go away.

"Help me up from my
beaten

silence.

morning

is coming.
without my hearing
what to do.

place

nowhere to go to—e
you know,

go by the evening train."

try to

remain

for a day or two. Come," she said presently,
back again. For
I

could not help
The matt?

pain,

action lay beyond
him.

go
away,
again

his ear against her
memory,

a text to
trust

Apart from the
less of her.
 time become habit
the lonelier parts of
 the paths

people
part

people
part

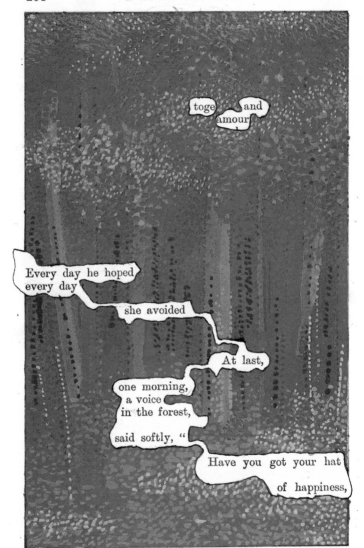

toge and
amour

Every day he hoped
every day

she avoided

At last,

one morning,
a voice
in the forest,

said softly, "

Have you got your hat

of happiness,

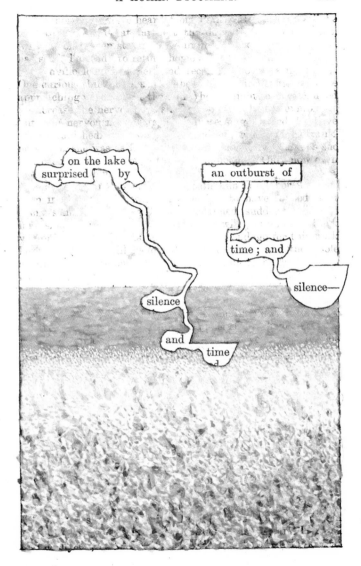

on the lake
surprised by

an outburst of

time ; and

silence—

silence

and

time

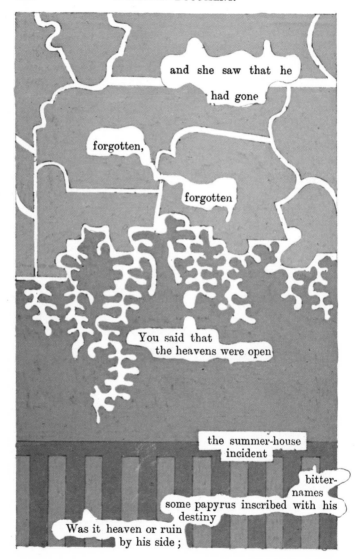

and she saw that he
had gone

forgotten,

forgotten

You said that
the heavens were open

the summer-house
incident

bitter-
names
some papyrus inscribed with his
destiny
Was it heaven or ruin
by his side ;

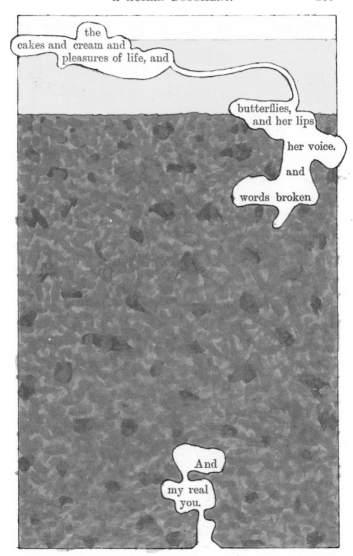

the
cakes and cream and
pleasures of life, and

butterflies,
and her lips

her voice.

and

words broken

And

my real
you.

—I foresee it all.
in the eyes—

in the garden,

little to say.

a crumpled

last night.

turn the dark lamp—

CHAPTER XXVII.

death seems day by day distincter;

a recollection

I foresaw

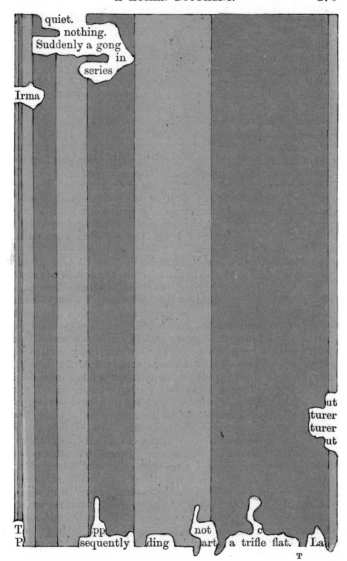

quiet.
nothing.
Suddenly a gong
in
series

Irma

ut
turer
turer
ut

T
P

pp
sequently ding not
art a trifle flat. La

T

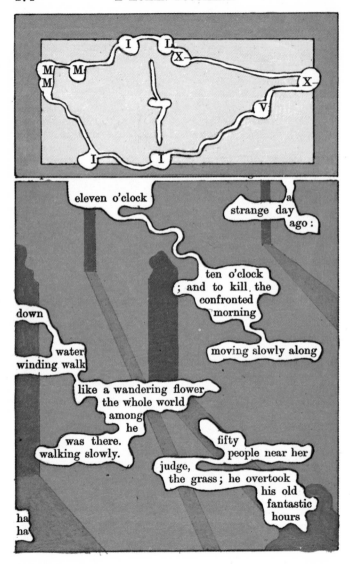

eleven o'clock

a strange day ago :

ten o'clock ; and to kill the confronted morning

down

moving slowly along

water winding walk

like a wandering flower the whole world among he was there. walking slowly.

fifty people near her

judge, the grass ; he overtook his old fantastic hours

ha ha

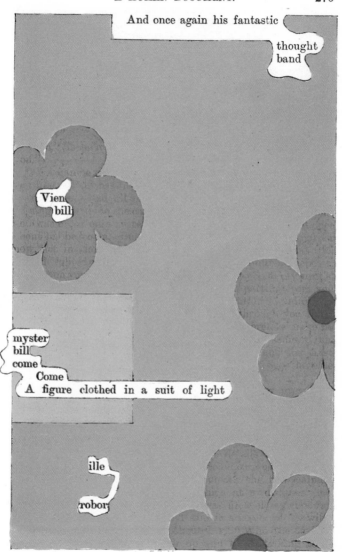

And once again his fantastic

thought
band

Vien
bill

myster
bill
come
Come
A figure clothed in a suit of light

ille

robor

the moment
changed, a
moment ago

Ah,

sidling
coming
to me.
prosperity.

clairvoyance,

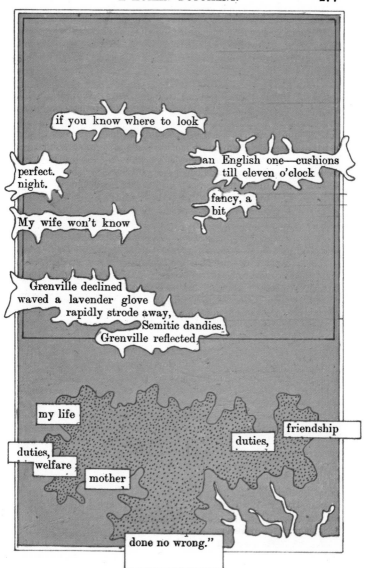

if you know where to look

an English one—cushions
till eleven o'clock

perfect.
night.

fancy, a
bit

My wife won't know

Grenville declined
waved a lavender glove
rapidly strode away,
Semitic dandies.
Grenville reflected.

my life

friendship

duties,

duties,
welfare

mother

done no wrong."

deep quiet

on the green floor

suddenly

influence of the past.

"We know little," he reflected, "when we enter on such a situation as mine, what problems it may in time reveal to us. It is like a plant whose thorns sleep in the sprouting stalk. It must root itself and grow in our lives till we really can know its nature. This man," he continued, "I can't be uncivil to him. Why should I be? On the contrary, I will, unknown to him, do him any good turn in my power. Only it must be unknown to him. I will never have him thanking me; and never from him will I take the smallest favour. And Irma what of her? Does the situation to her seem as hard as it does to me? She appeared this morning to be such a complete mistress of it! I ought to think of her far more than of myself. My moral anxiety was just now too selfish. And yet, in a way, things are simpler for her than for me. However civil and friendly she may be to her husband, she is merely paying him what is his just claim. He will not put, and he will not ... on her goodness which would ...

sometimes far more rapid
sometimes far slower,

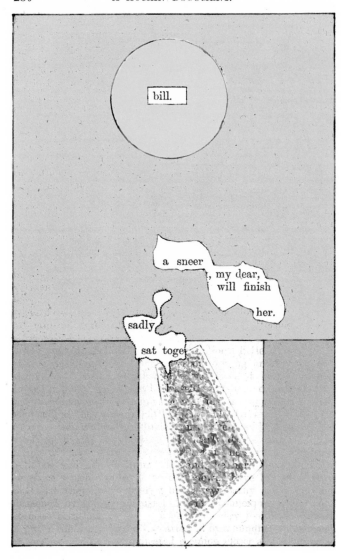

bill.

a sneer

, my dear, will finish

her.

sadly

sat toge

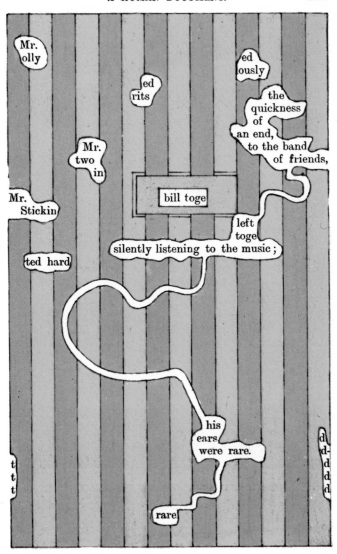

Mr.
olly

ed
ously

ed
rits

the
quickness
of
an end,
to the band
of friends,

Mr.
two
in

bill toge

Mr.
Stickin

left
toge

silently listening to the music;

ted hard

his
ears
were rare.

d
d-
d
d
d

t
t
t

rare

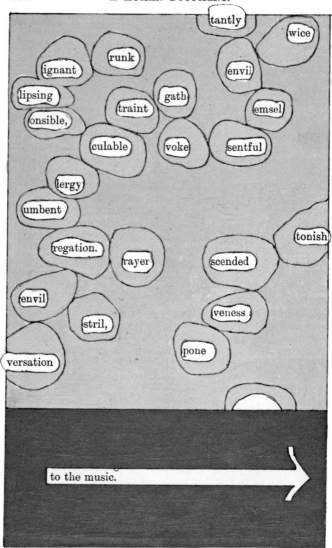

tantly
wice
runk
ignant
envil
lipsing
gath
onsible,
traint
emsel
culable
voke
sentful
lergy
umbent
tonish
regation.
rayer
scended
envil
veness
stril,
versation
pone

to the music. →

"What!" asked Grenville, after an expression of sympathy, "what is it that has put him out so suddenly?"

"I think I can tell," she said. "This dress I have on to-day—it's a great deal too smart for the place—but it struck him how pretty I look in it; and he heard, in the hall or somewhere, a Russian Grand Duke admiring me. I knew exactly what passed in his mind; I have noticed in him the same thing so often. I became at once, for the time, a valuable possession in his eyes, and he was determined to show me off as his own exclusive property. He doesn't want me himself; and as long as nobody else does, he never would care if I lived and died alone; but the moment he is reminded that other people may admire me, he likes to take me about in order that they all may stare at me, but is perfectly furious if I give even a smile to them. This afternoon," she went on, "he waited till the gardens were full, and then he walked me about wherever the crowd was greatest, as if he were a peacock, and as if I were his tail. I was so nervous, for whenever I turned my head, I felt his eyes were on me; and he said 'Who are you looking at?' However, as you see, he is perfectly quiet now. He was angry with me on your account for no reason person morning, before you hear from me, we may perhaps have better than those we have been passing lately. If this is so, ... shall have a note by ten o'clock."

She was as good as her word. The note arrived punctually, and the news and the proposal conveyed in it were far beyond Grenville's hopes. Mr. Schillizzi and his boon companions would be absent the whole day, at a town some thirty miles distant, attending a sale of houses. They had, in fact, started already; and she proposed that Grenville should take her and the children to visit once again the hotel and the hunting-

like incense from some
musical with memories;

I know

you can
so very far

see the breast on
every star

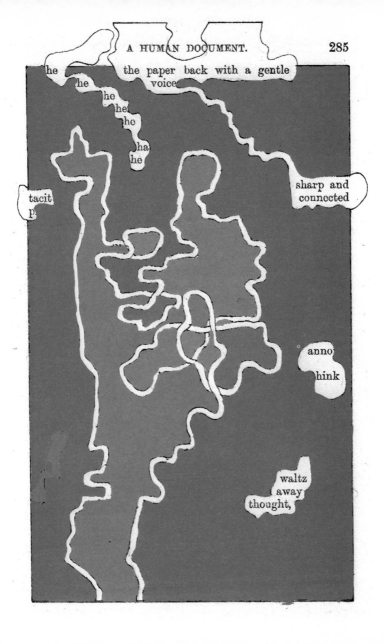

he the paper back with a gentle
voice

he

he

he

he

ha

he

tacit
p

sharp and
connected

anno

hink

waltz
away
thought,

dissipation, and the animal curves taken by the plausible

night

morning

yesterday, and

to-morrow.

One whole day,
sponged out of
hours.

Even
morning,
when it came was
glib and
distant,

that music bored her, and that she was
going to ... heart ...
the second night, ...

five minutes
peeled
attention.

creditable
time
Silbersheim.

watch
Irma,
will you

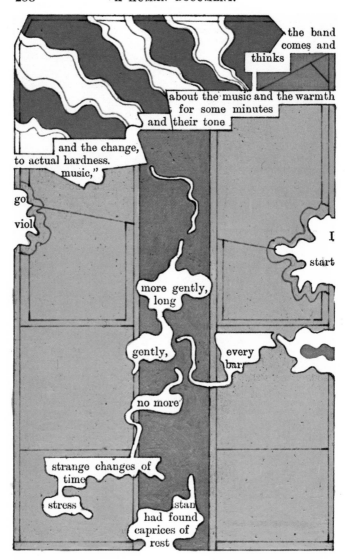

the band
comes and

thinks

about the music and the warmth
for some minutes
and their tone

and the change,
to actual hardness.
music,"

go

viol

I

start

more gently,
long

gently,

every
bar

no more

strange changes of
time

stress

stan
had found
caprices of
rest

" I shall have you again by and by," she said more calmly.

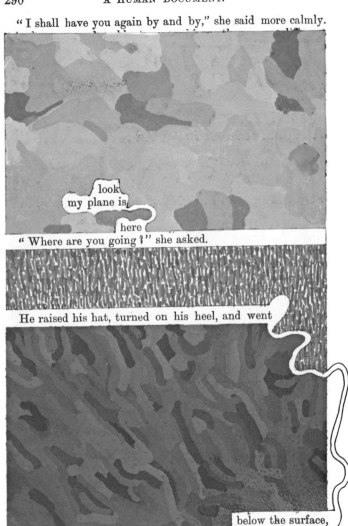

look my plane is here

" Where are you going ? " she asked.

He raised his hat, turned on his heel, and went

below the surface,

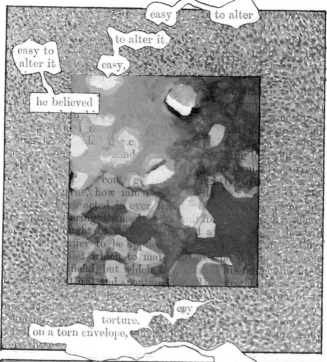

easy to alter

to alter it,

easy to alter it

easy,

he believed

torture,

cry

on a torn envelope,

a prize,

for dreaming eyes, for

eyes,

dream

The emptiest prize

pride

I see is dross beside

My broken dream of

art,

Licht

light

art impulses—

the impulse to complete as the impulse to

figure this last image

of despair he

began to shape

a

whole volume of

secret

faces

sound in his ears; and the vioces of the
noises in a dream.

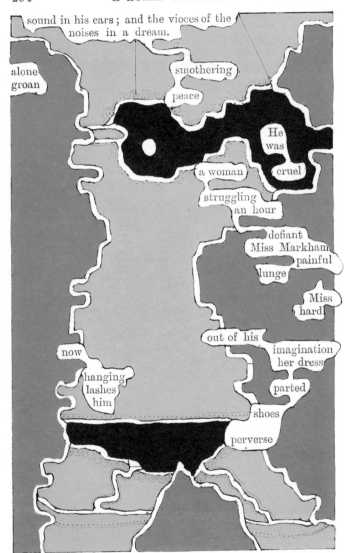

alone
groan

smothering

peace

He
was

a woman cruel

struggling
an hour

defiant
Miss Markham
painful
lunge

Miss
hard!

out of his
now imagination
her dress

hanging
lashes parted
him

shoes

perverse

a walking-
pocket-handkerchief

entered,

good-morning
handkerchief
Just smell
the world

ten guineas a bottle. Our
mischievous
bottle in bed-

I like it.

o
Grenville,

I
have so many buttons I may as well begin undoing them.
Help me. There's no one coming.

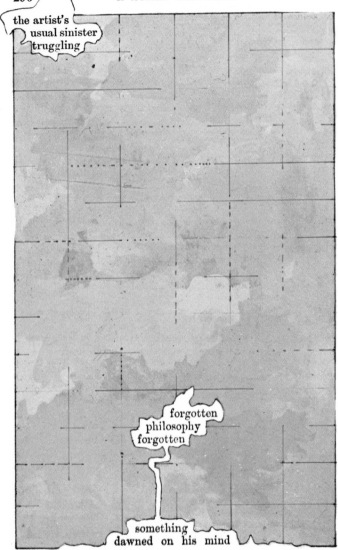

the artist's
usual sinister
truggling

forgotten
philosophy
forgotten

something
dawned on his mind

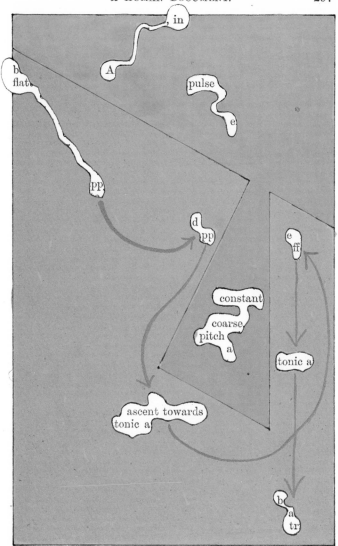

chance words

His aim was not to think. His aim

committed to music

liquid music

Let me live my life

no matter how the mountains fall

libretto. "Let me live my

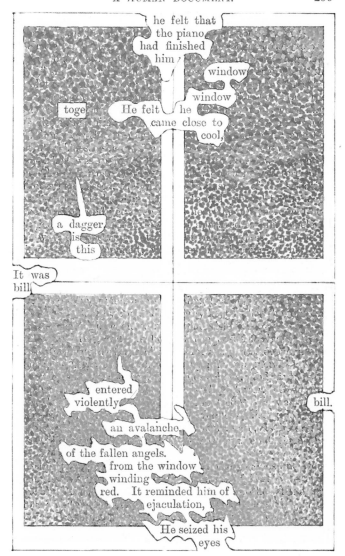

he felt that
the piano
had finished
him

window

window

toge He felt he
came close to
cool,

a dagger
is
this

It was
bill

entered
violently

an avalanche

of the fallen angels.
from the window
winding
red. It reminded him of
ejaculation,

He seized his
eyes

bill.

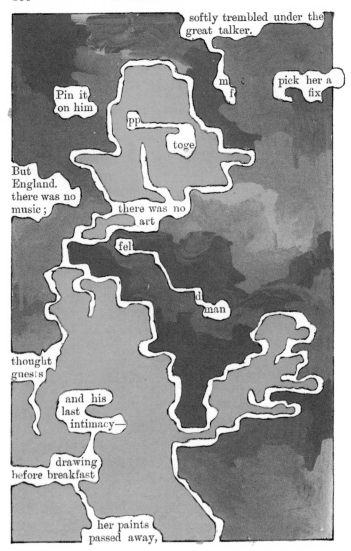

softly trembled under the
great talker.

m
f

pick her a
fix

Pin it
on him

pp

toge

But
England.
there was no
music ;

there was no
art

fel

d
man

thought
guests

and his
last
intimacy—

drawing
before breakfast

her paints
passed away,

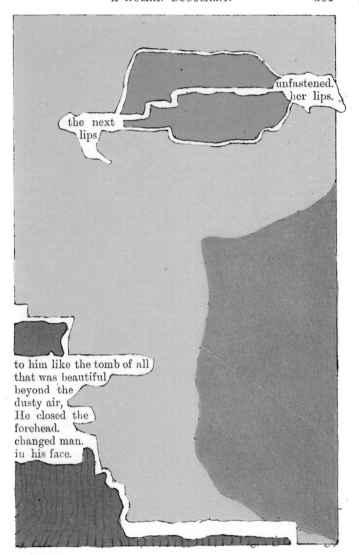

unfastened.
her lips.

the next
lips

to him like the tomb of all
that was beautiful
beyond the
dusty air,
He closed the
forehead.
changed man.
in his face.

sorrow.
materials.

CHAPTER XXX.

The emotions of men

hell is
torments;

tongs,
supplied

separated
once for all

... This reads like a fragment from some book of theology ... the inward confession of an ordinary ... God, but a woman ... woman whom, according to theologian... no business to love. But with an extra... theologians say ... the woman represents everything ... knowledge and ... committing against her ... of treachery. And my will ... consented. But ... the ... were ... consented ... whenever this has happened ... monkish specialist ... —a red-hot ... through the ... of my soul, cutting ... me all that in myself I respected, ... leaving ... for the first ... I know what guilt meant ... remember a certain morning ... better now. What ... me on that occasion, as it were a sense of guilt was ... not ... distrust of the ... situation. For so far as ... woman is concerned ... the first time in my life I was beginning to ... Theologians and ... that they think sacred, that a new inward light was the ... great the darkness is :

... hard to me. You have tried me. But what of that ... must I be worth if I could not bear such trials? How ... here at the first acute suffering I fail away! And yet ... going to take my own way to heaven, without ... good ... it ... this ... suffering ... Seeing ... on the page, and abruptly shut up the book ; ... few moments, ... write a letter ... to find ... form a beginning ... thus—

TEN YEARS' TRAVEL AND
SPORT IN FOREIGN LANDS;

soften her heart

as follows;

toge

communication from a man to a woman, made under
instances which are sufficiently explained by what he
and I want you to tell me, if you will, how one should
affect a woman receiving it. Is there
could touch her, or appeal to her
the writer, if having ended for a
by driven him away from her
out at length

you feel that our relationship will
one with you and towards women your own
and your own—I will not ask you to let me again
and I will ask you one thing, both for y
cutting yourself off from the past that
together, even while you condemn it, be just to
own heart you can speak better than
to do is to tell you about mine; for I
become things which perhaps you hardly
will not only make you (so I venture to
kindly of me, but will also prevent your
yourself. I want to lay bare before you all
me, and been, sad am, so far in my life
or own; and if in this you see anything th
I ask you not only to relent a little tow
remember that this is truth and goodness is
nice, and is a pledge of your own
to truth, is not a man's truth to a woman's
sacrifices in order to life come to her. Listen
for your sake I have sacrificed or y
vantages, I have talked only enough of the
such circumstances as admit of my point
Forgive me for alluding to this. You know
you do know how completely, in other ma
a parallel sacrifice. I have made my self
endless except for you. I don't say that
but do his past the unusual flight of

only toge alone.

loneliness is. throb of my watch, long shrivelled aspiration

I have something left two things left.

the other thing

Your image I cannot get rid of it.

from you? If you do not scorn me for this degrading test to
which I have put myself, you will see how it at least proves
the strength of my love for you. And perhaps the very
strength of my love will make you despise me yet farther. If
it does, I have but one thing to ask of you. Grant me one
final kindness. Let me see you once again; and when you
are saying good-bye to me—is it your contempt or pity? Is
that a great deal to ask, considering our past? Does all our
past mean nothing? Was it the dream of two wicked and
faithless children, who get each other into trouble, and then
leave each other? This I may do I know, so far as regards me.
I cannot believe that it was that, so regards you, when I
remember the words your lips have whispered in my ears,
your eyes with all your soul in them as they married them-
selves to mine, and the love that shone and revealed itself in
all the transfigurations of your face.

"Do you know these verses? They are not mine, except
that they speak my meaning—

 "'Ah, dear, but come thou back to me!
 Whatever change the days have wrought,
 I find not yet one lonely thought
 That cries against my wish for thee.'

This letter he sealed up in an envelope, on which he put no
address, merely the word "Private"; but which, having
written the following few lines to accompany it, he enclosed
in another, directed in all due form.

"Dear Mrs. Schilizzi, forgive me for troubling you; but
you will find, I think, that the enclosed belongs to you. It is
evidently strictly private; so I enclose it in a sealed envelope
in order that, if by accident it fell into other hands, there
should be no chance of its being read inadvertently. Pray
examine it, and let me know of its receipt by the bearer.
 "Sincerely yours, R. GRENVILLE."

Summoning his servant, he asked him to procure a horse,
ride to Lichtenbourg, and deliver the packet personally. "It
contains," he said, "important papers, and must be put into
the lady's own hands. You must learn from her maid when
she is disengaged, as it wants an immediate answer; and
unless you can find her alone, and able to attend to the

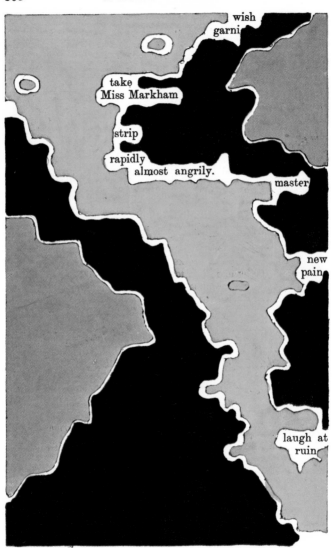

wish
garni

take
Miss Markham

strip

rapidly
almost angrily.

master

new
pain

laugh at
ruin

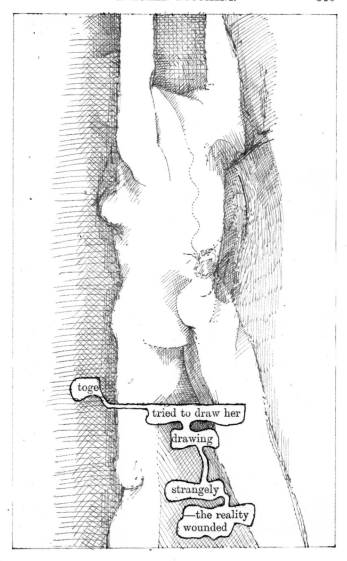

toge

tried to draw her

drawing

strangely

—the reality
wounded

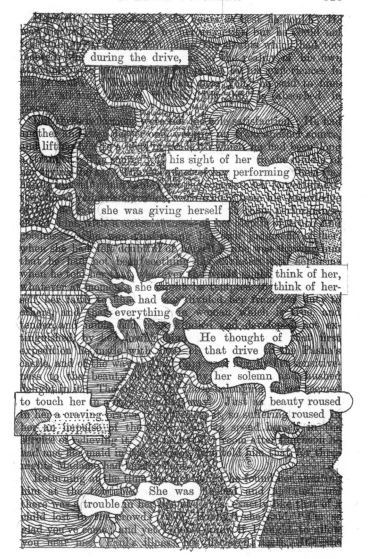

during the drive,

the lift

his sight of her performing

she was giving herself

think of her, think of her—

she had everything

He thought of that drive

her solemn

to touch her beauty roused roused

a craving an impulse

She was trouble

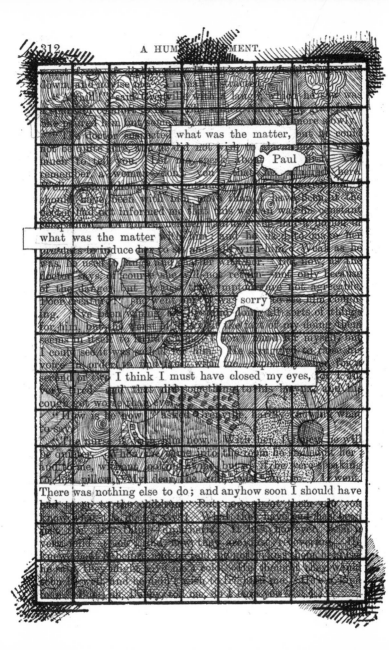

She looked into his eyes searchingly. He tried to shape an answer, but his lips only trembled. She understood him. Her eyes told him so. She leaned towards him and continued. " All this," she said, " is only the preface to my troubles. The children, though they are supposed to be recovered, are still, according to the doctor, in a very delicate state; and the great thing for them soon—not to-morrow, perhaps, but next day—will be change of air. They will want most careful watching for weeks and weeks. The doctor has lent me a book. For the last ten minutes I've been reading it; so far as I can see, it may be two months before we can be sure that they are strong again. Tell me—what am I to do? Where am I to send them? And must I go with them too? It would kill me to leave them; but then—Bobby—can you tell what I am thinking of? If I don't leave my children, I shall have to desert Paul. Give me your advice. Help me. Think for me. I am bewildered."

" I should like," said Grenville, " to share all your troubles, except your bewilderment. It is lucky I don't share that. I think your course is clear. Your children require you far more than your husband does. At all costs you ought to remain with them."

She walked to the window, turning her face away from him. He watched her. He heard a slight sob, and a slight movement showed that she was gulping down some emotion. Returning to him with swimming eyes, " Ah," she said, " but I feel this." She came close to him. She laid her face on his shoulder. " I feel this," she went on with difficulty. " I have never wronged my children; but I have wronged Paul; so I want to repay him over and over again." She looked up at him with a sudden momentary smile. " I shall make myself in that way more worthy of you. Don't be shocked at what I say. I dare say you don't agree with me; and so far as my thoughts go, I can't think I have wronged him. But from habit, from the way one's been brought up, from the way even conventional opinion has somehow got into one's blood, I feel that I have wronged him, though I dare say the feeling is irrational; and I want to cauterize this feeling by suffering for him—by wearing myself out for him."

" Irma," he said, " whatever my thoughts may be, I too at times have a feeling resembling yours. Till now I have been shy of telling you of it; but I can never again make a secret

chance

back here in the early morning having arranged everything."

will be

"Will you really," she said, "do all this for me?"

Her wondering incredulity, which melted as she spoke into gratitude, profoundly touched him. "Do me one little kindness," he said. "Lend me the doctor's book. I should like to look at it during my journey."

She gave it him and he was gone. He found the Count at home, who received him with the greatest courtesy, and at once placed the lodge at the disposal of himself or of his friends. He then hurried on to the train, which was to take him to the Princess. On the way he studied the book. He fancied that with more or less accuracy he could make out the general course which this disease, varying so in various cases, was taking with Paul Schilizzi. Whatever the mother had done and suffered for her children would not have surprised Grenville, though it might have moved him afresh to some new act of reverence for the beauty of her passionate maternity; but with regard to her husband, towards whom, as he knew well, patience was the highest feeling, and indifference the kindest, which his conduct and character made it possible for her to entertain or cultivate—with regard to her husband the case was quite different. That she should see him properly cared for and supplied with the best attendance, that whatever he wished her to do she should do and do willingly, this was natural enough. But what she had been doing, still more what she wished to do, went far beyond this. So far as his wishes went, his illness made few claims upon her. To him a nurse's care would have been just as welcome as hers; and the only thanks she received were either neglect or anger. And yet, in spite of this, she longed to do for him whatever was hardest—whatever to herself was naturally most repugnant; and what it was to which she was thus devoting herself, Grenville realized now, for the first time, as he read the account of the disease, and the attentions which were required by the patient. She had mentioned to him lightly that the symptoms were not agreeable. He now saw from something else which had been told him by the doctor, and which fixed his attention on certain special paragraphs, that "these not agreeable symptoms" really comprised everything which could try and nauseate constitutions far stronger than hers. The infected air alone would for her be physical martyrdom; and there was nothing to sustain her, not even the sense that she was wanted—nothing but the passionate wish to be true to

an ideal of duty. And for the sake of this she had not only
watched and suffered, but had done so, despite all provocation,
with a tender and unfailing patience. These thoughts pos-
sessed him during the whole journey. "Quia multum amavit!"
he several times exclaimed to himself; and then he said,
"Let me only be worthy of her, let her only love me, till I
die—and I shall not be afraid of death."

The Princess had been informed by telegraph both of his
coming and of the cause of it; and both were her idols.
She was awaiting him impatiently. He told her of the
scheme he had proposed for sending them to the Count's
hunting-lodge together, with all details as to the neighbouring
doctor. She approved highly, praising his readiness of
resource; and when he asked her if she herself were coming,
she answered petulantly—

"Of course I am, as if she resented its being doubted.
"My maid will see about packing my things to-night, and if
the children can be moved to-morrow, I shall be ready to go
with them. But the lodge—will the lodge be ready."

"Yes, it will," said Grenville. "There is a train which
passes your station at three o'clock in the morning. I return
by that. I shall reach Lichtenborg by seven. I will ride
over to the lodge. I can get there by half-past ten, and I'll
engage that by to-morrow afternoon the whole place is ready
for you."

"My poor friend," said the Princess with motherly pity,
"you're almost dropping with sleep. You look yourself as if
you'd been ill enough for all three of them." Grenville
laughed and roused himself, for he was indeed nearly
exhausted. "I tell you," said the Princess, "who causes me
most anxiety. That's Irma herself. Of course in remaining
with her husband she incurs the very gravest danger; and
from what you tell me her husband does not require her."

"I won't be sure," said Grenville, "how far she realizes the
risk; indeed I myself till this afternoon knew very little
about it; but I made her promise me that, at all events till I
returned, she would stick to her children, and leave him to
the doctor and the nurse."

"I," said the Princess "will write her a note for you to
give her. Any sort of paper will do. I have one here.
Will you lend me a pencil. Read it," she went on when she
had finished.

Every time you get this letter—

you have to give screw

the Princess,

on a sofa the porter found himself damp

and it was not

last night's smell

instant

mistress instant mess

the door of her bedroom opened;
and a diaphanous
dressing-gown

softly came

eagerly

through. As she did so

she said to him. have
what you will
but suddenly

suddenly

night, and the room

, I did whatever there was to do.

; and it seems to me now like running away

pain; and yet, when you speak of them, you disarm me. I have not the resolution to leave them; though—don't you think this?—for a week or so they could do without me."

"You quite forget one thing," he urged. "You might by remaining here make yourself unable to go to them for many a week, or, Irma, perhaps for ever. Have you any right to run that risk? Have you the heart to do it? You wouldn't run the risk of leaving them alone in the street. Can you bear the thought of leaving them alone in the world? As for your husband, you may safely commit him to the Princess and I will remain here also to do whatever I can do."

"I yield," she said. "I see that you must be right. To be away from them costs me far more than to remain in it. Go, best friend, and arrange things as you please for me."

A horse was ordered for Grenville, whilst he ate a hasty breakfast, and soon on his own horse, by the familiar hunting-lodge, making all necessary arrangements against Mrs. Schilizzi's arrival. Nothing escaped his forethought. Various provisions he ordered from the hotel, and some articles of furniture which the manager kindly lent him. He had also a long interview with the doctor. Returning to Lichtenbourg, he found that the Princess had arrived, who was delighted—so far as she could understand—of such an emotion—at finding her—was not dreaming that it had needed seconding—ordered—by the ever-useful Fritz, and almost before she well knew what had been done, her boxes had been packed and sent off, whilst a couple of servants, whilst a capacious landau, specially constructed for invalids, was waiting at the door, in the warm afternoon sunshine, ready for herself, a nurse, and the two children. The briskness of the Princess's manner was of great service on the occasion. She told her niece she was "silly and wrong and selfish" for having any reluctance to do what so clearly was pointed out to her, not only by duty, but by ordinary commonsense; and with a semblance of anger which acted like a moral tonic and was sweetened at the same time by an under-current of deep kindness, she almost drove the whole party out of the house into the carriage, where she carefully packed the children, kissing them whilst she did so; and they all drove off she stood waving her wrinkled hand at them, and forcing a cheerful smile, till a turn in the road hid them; and

toget
refrain

from your anxieties.

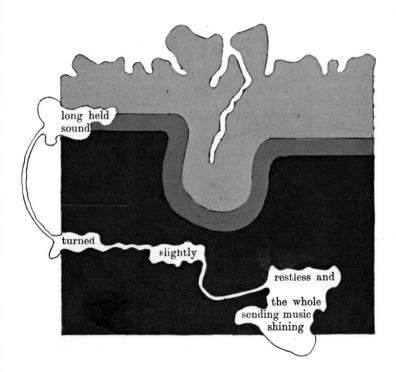

long held
sound

turned
slightly

restless and

the whole
sending music
shining

nobody without such a tube could perform it

"Never," said Grenville, and I only photograph afterwards."

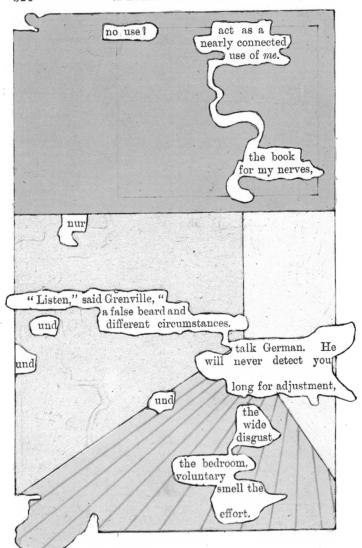

no use?

act as a
nearly connected
use of *me*.

the book
for my nerves,

nur

"Listen," said Grenville, "
a false beard and
different circumstances.

und

und

talk German. He
will never detect you

long for adjustment,

und

the
wide
disgust.

the bedroom,
voluntary
smell the

effort.

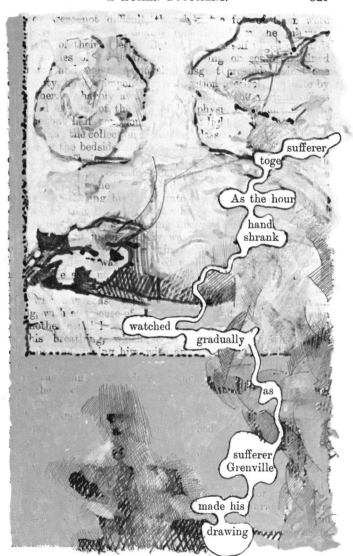

sufferer

toge

As the hour

hand
shrank

watched

gradually

as

sufferer
Grenville

made his

drawing

"It's a grave case," he whispered ... as its course slowly;
but the false ... continued to increase in the throat.
Stay—let us wake the nurse. You have relieved her long
enough; and I will finish what I have to tell you outside."

He touched the sleeping woman, who opened her eyes
instantly, and resumed with a mechanical readiness her own
station by the bed. He gave her a few instructions, then
went out with Grenville.

"I am aware, Herr Grenville," he said, "that I may speak
to you quite freely. In fact you can hardly have mistaken
my meaning, when I said to you not long since, that Herr
Schilizzi was not in good health when this disease attacked
him. Did I tell you that in the hearing of others, as well as
of myself, he voluntarily admitted the fact, making a joke of
it as he did so? He'll find that it's no joke now. His body is
at this moment a mass of complicated corruption. He may
pull through this attack. I shall judge better to-morrow; but
I think it probable that within a very short time from now we
may be driven to an operation on the tract ... If that is so,
it will give us one hope more, and our only hope, though one
which is too frequently dis...

They were by this time in the garden ; and touching Gren-
ville's arm, the doctor s... now let me prescribe
for you. Go to bed ... ing which I shall
follow myself."

For a time, however, ...ville had no wish
to do so. One delight in the middle of trouble was over-
whelming him, and this was ... of tasting the pure
night ... few ... trees and on the beds of
sleeping flowers ... approached his face to a rose-bush, and
the ... of the night ... ized him. He was conscious of a
scent of ... exhilar... the ... way
rapidly ... the ... was more
light ... the s... would
account ... the remoter parts of stars, ... where ;
and having ... full of moon ... ller
of the morning ... ing-up alrea... he ... of the
silvered foliage.

Thanks to the faithful ... who ... the hall to
... for him, he easily gained his room ... his rest was
profound and dreamless. slept

His first care next morning was to inquire about the con-

last week I had my false membrane sent

the mouth of the opera

chance lies in my opera

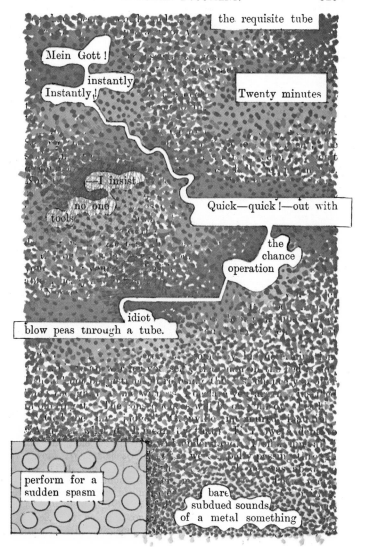

the requisite tube

Mein Gott !

instantly
Instantly !

Twenty minutes

I insist

no one
tools

Quick—quick !—out with

the
chance
operation

idiot
blow peas through a tube.

perform for a
sudden spasm

bare
subdued sounds
of a metal something

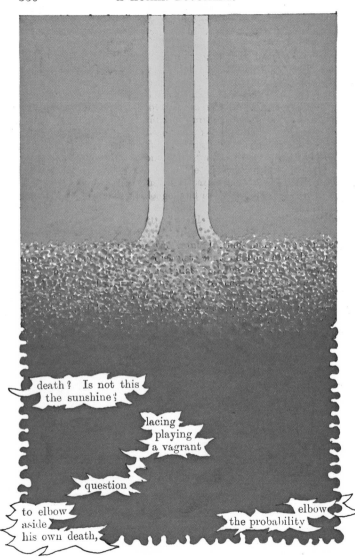

to him again and again ... but he had resolutely refused to dwell on ... on the prospects which lay beyond it, and absorbed as he had been in practical and painful effort, he had repelled it easily.

But now it presented itself to him more importunately and vividly; and he felt he had earned a right to speculate on the consequences of a death which he had risked, and perhaps forfeited his own life to ... This mood, however, did but last for a moment or two. He had hardly yielded to it before it shocked and disgusted him, and he presently exorcised it by sending his thoughts forward to the relief, if not to the pleasure, which he would be bringing to Mrs. Schilizzi by news pointing to the recovery, not the death, of her husband. He soon forgot everything else in this. The pleasure to himself even of being once more in her presence, and of reading the secret in her ... which swam in them through all her trouble, was a prospect which gave place in his mind to the pleasure of ... the relief which, unconnected with himself, would come to her from the news he brought her.

As he approached the lodge, the first ... thing that caught his eye was her red dress and ... parasol, motionless by the border of the lake. At the sound of hoofs she suddenly turned round, staring at him, as doubtful as to who he was or what was his errand. As he drew near, however, and as she recognized his face and his expression, she eagerly came forward with a smile of hope and of inquiry.

"I have come," he said, "to relieve you of the anxiety which I know must have been wearing you out here. You got the note which I sent over this morning?"

"Yes," she said. "How good of you! It arrived two hours ago."

"Well," he continued, "I have a later bulletin for you. He was far easier when I left him than he has been for the last twelve hours. You need not fret yourself because of your being here. There is nothing you could do for him that is not done by his attendants; and your presence might excite him ... quite quiet.

"And has he," she said, "not asked for me?"

"He has asked for no one," said Grenville. "He has not mentioned your name."

He wondered, as he told her this, whether she would be hurt

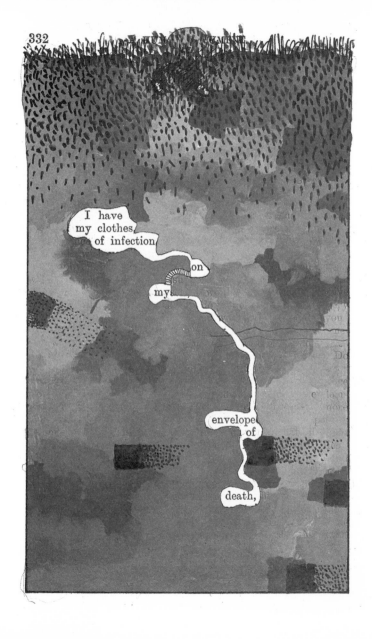

I have
my clothes
of infection
on

my

envelope
of

death,

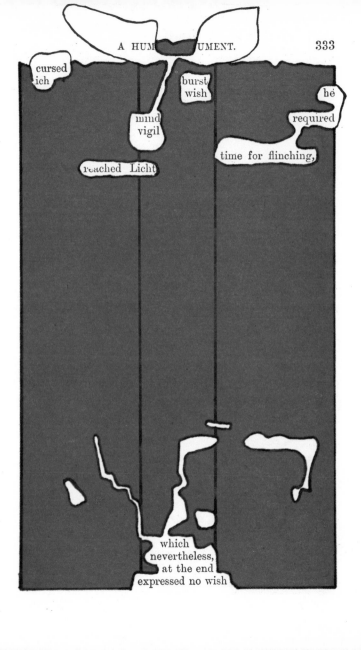

cursed
ich

burst
wish

he

required

mind
vigil

time for flinching,

reached Licht

which
nevertheless,
at the end
expressed no wish

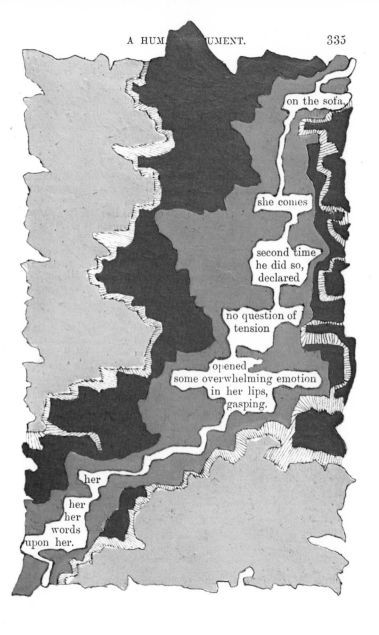

on the sofa,

she comes

second time
he did so,
declared

no question of
tension

opened
some overwhelming emotion
in her lips,
gasping.

her

her
her
words
upon her.

"Oh," she exclaimed ironically, "and so you have come... have you? Much good that will do! You may at least ... voice to answer me."

Here, however, there was a movement made by the doctor, who had been watching Grenville intently, and listening to the ... emitted by him; and now going up to him, and taking him roughly by the arm, he led him out of the room with a [that ensured] compliance. "Go," he said, "... back to bed directly. In a few minutes I will be with you. Your life may depend upon your prudence."

Almost stupefied by the scene he had just gone through, Grenville went to his room with a dull mechanical resignation, and the doctor returned to the other two before either of them had uttered another syllable. He shut the door with a bang. In his cheeks was a flush of anger. He strode up to Mrs. Schilizzi and confronted her with a look that terrified her. "Madame," he said, "that gentleman who has just left us has indeed done what you taxed him with, and kept back from you —and begged me to do so also—the most remarkable incident connected with your husband's illness. Seeing, however, the manner in which you treat him, it will be best for you—it will be best for every one—that I tell you the whole truth. I cannot allow you to be ignorant of it. Herr Grenville, madame, whom you charge with having killed your husband, and to whom you say you will never again speak, when your aunt, the Princess, was disabled, and one of the nurses failed me, attended your husband himself during the most trying night of his illness, with a nerve and a care which few trained nurses could have equalled; and when, madame, that operation took place, which you blame him for having concealed from you, it was solely his heroism which enabled it to take place at all. With his own mouth," said the doctor, his voice rising, "he performed the desperate function of removing through the tracheotomy tube the membrane that was suffocating your husband. No man walking up to a cannon's mouth took his life in his hand more surely than did Herr Grenville then; he did it knowing that the danger was worse even than I dare explain to you; and events will have treated him with a favour which he had no right to reckon upon, it he is not now laying himself down in his bed to await the death from which he struggled to save your husband."

"Doctor," cried the Princess shrilly, "stop—I order you to

z

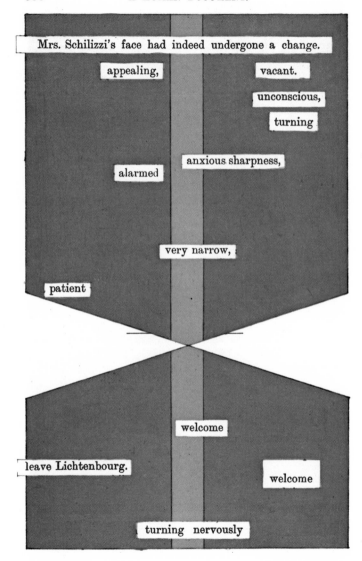

Mrs. Schilizzi's face had indeed undergone a change.

appealing,

vacant.

unconscious,

turning

anxious sharpness,

alarmed

very narrow,

patient

welcome

leave Lichtenbourg.

welcome

turning nervously

the

pale

pink with a faint

light

2,400
of them.

lying

saucers

lying

give me.

give me.

The second

message

to
the world

hushed

I may tell you I hope you are not suffering I may comfort myself with the confidence—the doctor gives me this—that your recovery will be rapid; and once more, oh, forgive me."

Then came these, of which every day had brought one.

"The Princess goes home this afternoon. Her ankle is almost well. I too must leave. I am obliged to rejoin my little ones. Thank you for your few words, which I could see you wrote with difficulty, telling me that my letters soothed and did not disturb you. I shall drive over to-morrow, perhaps taking the children with me, to inquire after you. And now shall I tell you one thing? Dare I? Will you think ill of me for it, considering what took place yesterday? Will you think—? Oh, Bobby, I don't know quite what I mean, but I will tell you what it was I did. Last night I was told you were sound asleep. My maid had just heard this from your servant, when I asked about you. She was in the passage outside your room. I asked her to look and ... Yes—you were sleeping. I came in myself on tiptoe, just to have one look at you; and then I stooped down and gave you one kiss on the forehead. I saw my little scribbles lying on the table, amongst your medicine glasses. It made me cry to think that such little things could please you."

"I am," ran the next note, "writing this in your hotel. I have driven over, with my two children, to ask for you, as I said I would. Send me a line—a word or two; or else a mere message. I hear you are much better. Oh, if I could only see you! But it would not be allowed me; and under the circumstances I ought not to ask it. Oh, to be with you again, and to hear your lips say, and to see your eyes look, the forgiveness that you have written to me! When I see you again will you be quite the same? Are you sure you will? I shall not be. I shall be changed; but if you still can care about what happens to me, it is not a change that will displease you."

Weak though he was, he had written her a short answer, as hers of the next day showed.

"You tell me," she said, "that the doctor thinks you may move soon. But oh, what do you mean by this—? You write 'If I die, leave my diary to you. It is full of you.' It is full of you and no one else. It is in a packet sealed up and directed to you. Why do you frighten me? And yet what

... getting ...

... getting quite

strong again.
quiet at first ;
in their minds,
as in the days

getting stronger."

... growing stronger, ...

of an unbelievable something into which his own life was
expanding. By midday he was breakfasting in the sitting-
room lately vacated by the Princess. Then followed his drive.
His first excursion in the environs of Lichtenberg had been
the walk he took on the morning when Mrs. Schilizzi had
explained to him that she wished he would rid her of his
company and banish himself to the Pasha's castle. That
morning he had hardly known where to wander, for every road
held some happy memory of her which would then have taunted
him in his misery. But now to these roads he was again
licensed to return: the happy memories again were beautiful

throughout his meal. the whole
bosom
broke out into masses of white and pink
penetrating
mories

The doctor that evening gave him the unexpected informa-
tion that, if he chose to do so, he would take proper pre-
cautions, and if he would not travel too far continuously, he
might leave Lichtenberg next day. And where, he asked
presently, "would you think of going?"

The question caused to Grenville a certain amount of
embarrassment, but without any actual untruth, he managed
to get out of it creditably. "The Princess," he said, "will
have me whenever I wish to go to her, but before doing that,
I must see Mrs. Schilizzi; so I thought of going first for a day
or two, to the hotel in the forest."

The doctor declared that nothing could be better than this,
as there, there was healthy and bracing to an extraordinary
degree. "In fact," he said, "I should advise you to remain
there till you are quite strong again.

"And now," said Grenville, "I must ask you an important
question, and I trust you to answer candidly. Do you think
that my health in any way has suffered, or is likely to suffer,
from what I have gone through? I say in any way; and you
will not misunderstand my meaning."

"Herr Grenville," said the doctor, "had your health been
less sound than it was some ten days ago, my answer might

have been either a doubtful or a painful one. I cannot say
that what you have suffered has left absolutely no effect on
you; but the effect, I can tell you confidently, will be no more
than this: your throat may be more delicate than it was before
—more liable to the attack, say, of some form or other of
laryngitis. I must advise you then to take great, though
not excessive, care of yourself, and not to neglect precautions
at which otherwise you might have safely laughed."

The first thing next morning a messenger was sent to the
hunting-lodge, with the announcement that Grenville would
follow in the course of the afternoon. He did so; but the
carriage being heavy, the journey was slower than he had
anticipated, and it was five o'clock before the manager of the
hotel was showing him into the rooms with which he
was so vividly familiar. [...] a note. It
said—

"I will wait in for you [...] come [...] me?
I wonder if you would be able [...]

He sat down, fatigued a [...] looked
about him for a minute or [...] jar which
would hold flowers [...] were wild-
flowers, but there we[re] [...] roses; and he
divined that these [...] come f[...] neighbouring
garden, which he [...] dew, had once
[...] in the h[...]

He longed [...] ing-lodge. He longed to
say that he [...] not only prudence, but an
actual sen[...] him to write and despatch
the follow[...]

"I [...] come [...] am not very strong yet.
You mus[...] the children with you."

An ans[...] in a folded scrap of
paper.

"Yes [...] come.

An hour [...] ing in his chair, he
heard in the passage a flutter of [...]. There was a
light knock at the door [...] children. They
came close to him, and g[...] faces to be kissed. He
looked for their mother. [...] left the door open. He
knew she must be coming. She stood presently in the door-
way. Above her soft black dress, her face once more to
Grenville suggested the petal of a pale geranium. There was

...she stood there a moment, a gentle hesitation,
and what her eyes suggested to him...the clear shining
eyes again. Their meeting was made easy by the children's
presence. There was no passion here...nothing but
a gentle and profound quiet.

"...rest. I am not going to have you stand-
ing...your chair, and I will bring mine beside you."
So...for a moment she laid her finger-tips on his
forehead, and murmured, half smiling, two lines of Shelley's—

"My hand is on thy brow,
And my spirit on thy brain."

She asked him how he was. She told him about the health
of the children. Then in a low tone she said a word or two
about the funeral and added,—

"I hardly...how...could really have been of no service.
The doctor...me that I had nearly been very ill myself.
That was the thing which really at last quieted me. I saw
witness borne by my body...done my...one say...my...
wouldn't believe my soul, though that said the same thing,
fancied it was deceiving me. I couldn't bring myself to
believe it. Why should the...of...be...the...the
the more convincing."

In their voices, as they spoke together, there was a note
of sorrow, but there was something...and...—a
tribute of reverence to the...catastrophe...
catastrophe. ...some dome...the ripple of death
talk, in which...her...the...of...the
the laugh of childhood. Their...and...
speak to them about their food...the...and...to
struggle with a child...how...the other by a...ven-
ture tragedy with...and...and...and...it
flitted from one...thing to another thing...and,
gradually became more...The...was...the
busy and getting...with sweetness when...were
arrived to summon them back to bed.

"Let them," said Mrs....the
way, and I will watch them from the...children
—go. Mother will come soon; and if you can catch a fairy to
show her. Only mind, it must be a good fairy.

She and Grenville went into the balcony, and watched the
two small forms flitting about below them. Presently from a

clump of bog-myrtle rose a large pale-winged moth, to which the
children instantly gave chase, jumping into the air, and reach-
ing their hands towards it. As she watched this incident, Mrs.
Schilizzi laughed. The sound was that unconscious ripple
which Grenville knew so well. He turned to her. Her face
was bright with a happy smile. It was a smile like the year's
first snowdrop.

"Bobby," she said, "you mustn't stay out too long. You
look so worn and tired. You had better come in now. Take
my arm; you are not too proud to lean on me."

She closed the window so that the light caught from him.
She seated herself beside him on a seat, and looked at him
gravely and in silence. As she thus made a slight move-
ment towards him, it, in passing gently and closely, like
the tendrils of a noiseless plant, her arms went about her
neck, and she just over whispering in his ear, Emma, from
this day forth shall I have you

"Hush, oh, hush!" she exclaimed softly, disengaging
herself. "I will often leave you, often, if you will let me
remain with you. But to-day you must let me nurse you. I
want to nurse you like a mother. You are very weak still, and
I cannot have you do too little for yourself. You are not strong
even

before separating

The wind was dying down before separating. They
had arranged, if the weather was fine, to go out walking
into the forest, and to sit together again on a certain beech-
tree, whose smooth stem still gave in their presence. The
morning brought with it all the sunshine they could have wished
for. The seated her couch, and having had a cup of tea, and the
above with the children along the broad moor, under a bough
which the squirrels still leapt in the morning. They found the
same seat in the woods in a face to face
ourselves

turn the dark lamp—

it. No—but before we are able, without offending the world, to establish a relationship between ourselves which the world can recognize, some time must elapse. If we alone were concerned such a question need not trouble us. I can never be yours more truly than I am at the present; but just as one dresses oneself in order to go into the street, so, if our relationship is to be shown to the world eventually, it would be an outrage not to dress it in the world's prescribed formalities. With me, then, the practical question is this. How, till this is done, can we best remain together? Shall I tell you what I have thought of?"

"Tell me."

"Do you remember how often I have talked to you about Italy? If we find it suits the children, shall we travel for some months there—say till the winter? This could be done without causing the least remark. Whenever it was desirable, we might stay at different hotels. There need be no division between us except to the outer eye; and if we are only wise in choosing our times and seasons, we need encounter no eye that would have any interest in observing us. What do you say, Irma? Speak to me. Tell me your opinion."

"Oh," she said at last, "it is all too delightful. Only, Bobby,—I wonder if you will understand me,—I don't feel that just yet it is right even to think of it."

"Never mind," he answered. "Think of it when you like. I dare say we are not both of us in a condition to travel yet; and meanwhile, whilst we rest here, I will remember I am your child, and after this, as long as you wish it, you must remember that I am as a brother."

She laid her hand on his, and her eyes were like skies unclouding. Suddenly both grew aware again of what had been escaping their eyes—the rustle of the leaves, the sharp singing of birds, and the life of a summer not yet out of its childhood. The freshness which they had known before on that very spot, rose out of the mosses, tingling in the air around them. The past began, like a slowly swinging censer, to scent up into the present its clouds of perfumed memory.

The same evening after dinner, as they sat together in the twilight, the charm of the future began to operate on their fancies, and the scenes glimmered before them which they hoped soon to visit.

"Have you forgotten," she said, "I have not forgotten it

the momentary picture of Italy with which once you stirred
and dazzled me? I remember your very words—boats gliding
on lakes with sails like the breasts of swans, the marble peaks
of the pure Carrara mountains, rising out of violet mists,
and glittering in a sky of primrose colour, the notes of the
Angelus trembling from craggy villages amongst the
Apennines."

"Yes," said Grenville; "we will see them all. We will
sit together above Como, in an arbour of which I know,
whilst the banksia roses round us are fretting the purple
twilight."

"And I," she said, "will not trouble you with questions
about our past. Whatever we ought to think of it we shall
learn to think. Our united lives will teach us."

This programme began to be realized sooner than they had
dared to anticipate. The whole party, Grenville especially,
recovered strength rapidly; and matters connected with the
estate of her late husband made it desirable for Mrs. Schilizzi
to go for a few days to Vienna. Grenville accompanied her,
now without anxiety. One morning when, as usual, he came
to her apartment to breakfast with her, she met him with a
look of excitement, holding in her hand a letter.

"What do you think?" she exclaimed. "I have only now
learnt it. Paul never told me. I have just heard it from
our lawyer. It was Paul who bought your house, that he
might sell it to Prince —— of ——. The Prince, or the
Queen, or the nation—I don't understand these things—will
give twenty thousand pounds for it more than Paul gave
you."

In blank surprise, Grenville sank down on a sofa, saying
nothing for a moment but staring at Mrs. Schilizzi. Then
the recollection came back to him of Mr. Schilizzi in the
train, and his glowing account of his operations in country
properties. "Tell me," he said, presently, "all about it.
With regard to that, and to other things, let us try and
understand the situation."

"So far as I can gather," he wrote that night in his diary,
"we could if we liked return to my old home and live there.
Unless it is resold—and there is no obligation to sell it—it
will entirely go to Irma, my little step-daughter; but it seems
to me better it should be otherwise. I
am glad of this, and she is glad also. We are glad we might

live there, for this reason—because thus we are enabled to
re....... do so. We will touch nothing of Paul Schilizzi's
money except in so far as we touch it for the distinct benefit
of his children. My old home shall never be my home again
through that. We both agree about this point. Our feelings
are perhaps ... in this ... mind. This is our ... deter-
mination ... can neither of us really believe that we have
done that ... wrong; but we do feel that we never could
re..... to him any benefits. Irma's business here is done,
........ it seems to
we start to-morrow. We start ... **.**
an unbelievable dream. We go to Vicenza first, and
think then to Siena. We shall see. The world is all
before us.

"This evening Irma asked me if I had read her diary. I
said I had not. I said that I felt as if to do so would seem
like implying a doubt of her. She said, 'No—no. I am
pleased that you should feel that; but indeed you need not.
I know that you don't doubt me; but I have been thinking
over the past, and I am horrified to see how **capricious** and
cruel I must have appeared to you. You *have* **thought me**
capricious and cruel. Don't deny it. I know you have.
Hush—don't answer me yet. Let me go on speaking. You
don't think me so now—you don't any longer doubt me; but
as to the past, I am certain you do not understand me. You
will if you read my diary. That was why I sent it to you,
and therefore, for my sake, read it. Nothing will divide us
then, I think—not even one jarring memory.'

"I told her I would read it; and we talked of other
matters, but just as I was going to leave her she came back
to the subject. She spoke half shyly. 'When you read it,'
she said, 'don't speak about it to me. I want to know that
you have read it through as a whole; but I don't think I
could bear—you see you have all my inmost thoughts **there—**
I don't think I could bear to speak about them **in detail,**
even to you. Do you understand me?' I said I did, and I
did. I shall open her volume for the first time to-night; and
each night during our travels, when I am alone in my own
room, I shall read a little."

The day following, as had been arranged, they all started
for Italy; and he studied the diary night by night as he had
proposed to himself. With regard to one point, however, he
found himself deviating from the course he had anticipated.

Instead of reading the volume straight through, he found himself instinctively turning to the records of those days when her conduct had so wounded and troubled him, when the ideal he had formed of her had become so distorted, and almost lost, and when his heart had been seared with a pain, the smart of which he remembered still. And here in her diary he at last found complete healing.

During all that time in London, when he had felt her to be treating him so ill, he discovered that in reality all her hours had been full of him. He compared carefully his own diary with hers, for those days when her notes to him had been shortest, or her words hardest; and all the anger which he had then felt against her, with a sensation of rapture he now turned against himself, taxing himself with selfishness, with want of patience, with a stupid want of understanding, and by the shadow which he cast upon himself, making her image brighter.

The following was her diary for her first day at her uncle's. It was addressed to himself, as it was on so many other occasions.

"What weariness all these hours have been without you! Now you are no longer with me, the sun seems extinguished, and all the air is waste. I have been to-day with my lawyers. How tangled and perplexing all my business seemed! Had you been with me to help me, everything would have been different. And how can I thank you? My mother-in-law is preparing to make my visit to her one of a series of engagements for me; she is going to drive me out to her neighbours' with both the windows closed whilst she wrapped with a rug her feet on a hot-water tin, and ... but she calls ... her laughing and joking I must dare not ... but I feel this — that she is spinning round ... circumstances, which all conspire to ... and ... keep me from ... I have some ... may be ... cannot be told ... last evening ...

wretched uncertainty ... your sake I wish to ... help me. I trust you.

stupid,

with
pages and pages
only these

"This morning I had two hours I couldn't

you?
you feel I felt
 Is it not strange

 I am doing it
I am doing it to you.'
you?"
 Then came her record

 alienation

 continuity

 and all through
have felt, night
with me,
this quiet '
intercourse,
 calm again.

 a strange thing

 urging on me

 woman is. A woman can

the first stones cast

against names

Words—words!
Make me
a rose

loving you

is contained in
her record of the

night

I can't write any more. —come !

toge

away

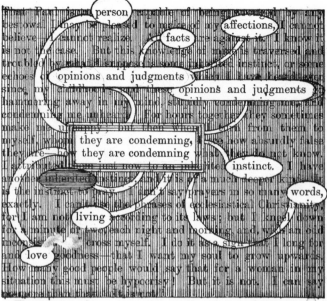

person affections facts opinions and judgments opinions and judgments

they are condemning, they are condemning

instinct. words, living love

Then came a day or two with entries like the following.

I will go with him to these odious races.

that at any moment he can call on me to exhibit this, so as to let him see, or let others see, that I am still keeping it for him. Oh, fool, fool! What does he think a woman is made of? Is a wife a husband's plaything? Has she no life of her

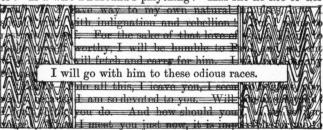

my much to you; and I feel angry for that very reason, and
vent my anger on you.

"Last night you were cold and distant. I was, I know;
but I didn't want you to be. If you could only have a little
more penetration, you would see that, when in speaking to you I
have seemed most hard and odious, I have really been
longing to cling to you, and tell you I was your own."

Presently came this passage, which, as Grenville read it, sent
the blood to his cheeks.

"I have driven you away, myself I invited you to go. I couldn't
help it. I should have gone mad if you had stayed—at least
I thought so. And now you are gone, till I see you again I
can write no more—" . . . "you back."

Then followed this, which, during his visit to the Pasha.

"I said I would write no more till I saw you, till I had you
with me again. But I must write. I must ease my mind
somehow. When are you coming back? Everything is blank
without you. Paul is rather poorly. I have been nursing
him as much as he would let me. That at all events was a
duty. But he would let me do little. He preferred the
company of—what shall I call her?—my rival—one of my
twenty rivals; and most of my time I am alone. Oh, Bobby
—what can I do without you? You will come back soon,
won't you? I don't know how to write to you."

Next day she wrote, "The children are both ill, as well as
Paul; so I could hardly see you now, dear, even if you were
here. All day I have been by their little beds; but all through
my care my heart is aching for want of you. I believe you
will come soon; for cruel as I think I seem to have treated you,
I believe in you so entirely. I am weary in body, and sick in
mind. Come to me."

Having studied these passages and others relating to the
same period, Grenville felt he had some principal right to the
secrets of the volume he was now gone. conduct that had
pained and troubled him was explained. He had felt, whilst
reading her account of the this, as if he was treading on sacred
ground; and he shrank from perusing these earlier parts
which referred to a period before . . . complexities had begun.
Her whole life lay, as it were, defenceless upon the pages, which
she had put into his hands. But still, that he
might not seem to be her confidence, or missing
anything which she might wish him to know, there was

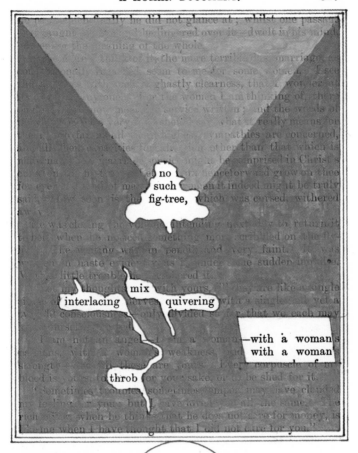

CHAPTER XXXIV.

GRENVILLE finished his reading on the night of their
arrival at Vicenza. They had travelled leisurely, stopping
three times on the road; and each night before he composed him-
self to sleep he had studied her pages by the light of two
...... candles.

Every doubt with regard to her that had ever troubled him
was now not only dispelled, but had given place to a confidence
even deeper than anything he had known before. Faith was
lost in vision. ... as he put the volume down, he was lying in a
great gaunt ... bare, which was an illustrating ceiling. The
walls of ... were festooned with flowers in rough ...
temper ... was tiled, and dingy from want of washing.
Musty smells, like ghosts, haunted the curtains. But as he
closed his eyes ... whole place was like paradise. He was ...
in that very town where he had ... one hour, and he ...
to awake to ... vision of another, ...

They were staying at different hotels. In the morning he
... impregnated all the air,
... with flowers,
... girls on the pavement.
... It was a dream come
... life ... her, and
and toge... ... pro-

sions were made by them, from ...
light. The voices of singing ...
air. Grenville thought of the ...
remembered morning ...

shadow
the fact

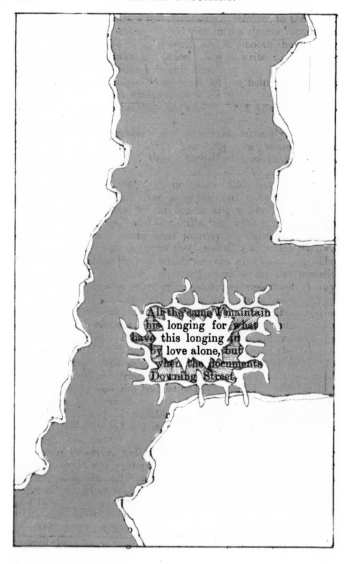

All the same I maintain
his longing for what
have this longing in
y love alone, but
when the documents
Downing Street

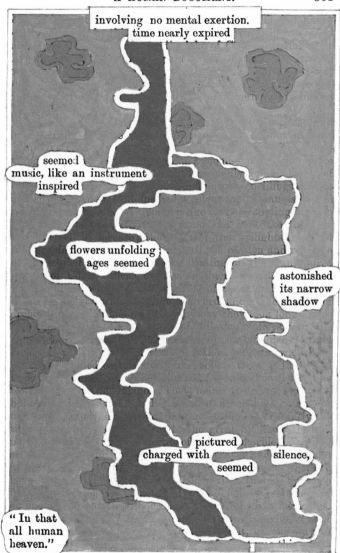

involving no mental exertion.
time nearly expired

seemed
music, like an instrument
inspired

flowers unfolding
ages seemed

astonished
its narrow
shadow

pictured
charged with silence,
 seemed

" In that
all human
heaven."

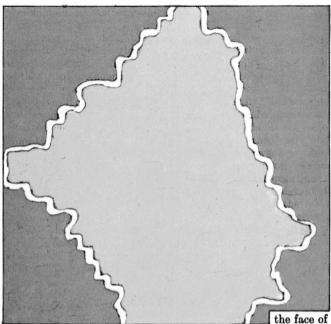

the face of
Sir Septimus Wilkinson, shining and swelling with the wish
to be intimate

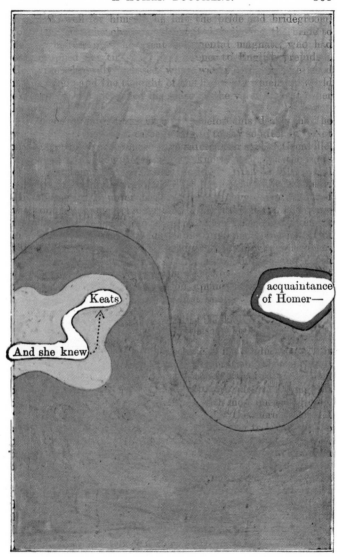

crushed us, and
slowly changed,
old prejudices
on which all our
been raised up,
old prejudices
reason, against

He
He

music

The spot he had indicated was just below the garden, and could be reached by a winding road, practicable for a light carriage. In the hush of the morning, when the light was a white dimness, a little pony-chaise stood at the villa door; and Grenville and his wife crawled in it down the steep descent, whose rough zigzags brought them close to the sea. In the universal stillness the noise even of that light carriage was startling. Every stone which the pony's hoofs loosed had been audible separately as it rattled down the hill. But on reaching the grove of pines, where the ground was soft and velvety, one sound alone came to their listening ears; and this was the long sigh and the falling murmur of the waves.

They stationed themselves on the margin of the grove, just where the sands bordered it. The air was fresh with the night which had hardly left it, and the darkness of the night was still in the solemn blueness of the sea. Before them for miles and miles were the curves of the vast bay, ending in a horn of mountains, which were now half lost in mist; and along the sea-line, and over the high hill-country inland, white houses were sprinkled on purple and gray shadow. But all as yet was sleeping. Even the waves fell like a dreamer moving on his pillow. Nothing was awake but smells of brine and dew.

"Let me taste the world," he said, in a low voice to her. "Let me inhale the morning. Ah, there is life—life, everywhere. Soon you will see it waking. Look, look!" he exclaimed, as an arrow of rosy gold shot through the air and struck on a crest of foam. And now a change came. Far away the mountains began to flush; coloured vapours steamed out of distant valleys; and wreaths of smoke from one place and another were seen rising in columns of shining silver.

She felt it difficult to speak. She could only look at him anxiously.

"Did you ever," he asked her presently, "hear a story of Mirabeau—I dare say untrue, like most stories of death-beds—how he told them, as he was dying, to throw the windows open, and said, 'Sprinkle me with rose-buds, crown me with flowers, that I may so enter on the eternal sleep'? I think that was rather theatrical; but still I can feel a meaning in it. I should like to be buried where flowers might sprinkle

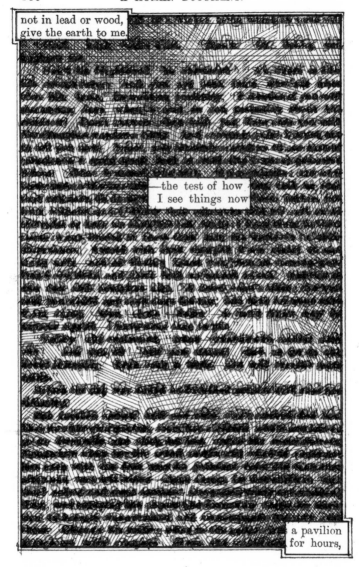

not in lead or wood,
give the earth to me.

—the test of how
I see things now

a pavilion
for hours,

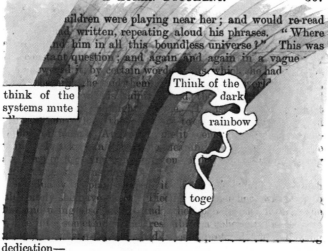

hildren were playing near her; and would re-read
d written, repeating aloud his phrases. "Where
him in all this boundless universe?" This was
constant question; and again and again in a vague

think of the
systems mute

Think of the
dark

rainbow

toge

dedication—

" TO THE SOLE AND ONLY BEGETTER OF THIS VOLUME.

by whose side I shall lie,

bones my bones

my best,
perpetuate

equal
page

for

THE END.

NOTES ON *A HUMUMENT*

Like most projects that end up lasting half a lifetime, this work started out as idle play at the fringe of my work and preoccupations. I had read an interview with William Burroughs* and, as a result, had played with the "cut-up" technique, making my own variant (the columnedge poem) from current copies of the *New Statesman*. It seemed a good idea to push these devices into more ambitious service.

I made a rule; that the first (coherent) book that I could find for threepence (i. e. 1¼p) would serve.

Austin's the furniture repository stands on Peckham Rye, where Blake saw his first angels and along which Van Gogh had probably walked on his way to Lewisham. At this propitious place, on a routine Saturday morning shopping expedition, I found, for exactly threepence, a copy of *A Human Document* by W. H. Mallock, published in 1892 as a popular reprint of a successful three-decker. It was already in its seventh thousand at the time of the copy I acquired and cost originally three and sixpence. I had never heard of W. H. Mallock and it was fortunate for me that his stock had depreciated at the rate of a halfpenny a year to reach the requisite level. I have since amassed an almost complete collection of his works and have found out much about him. He does not seem a very agreeable person: withdrawn and humourless (as photographs of him seem to confirm) he emerges from his works as a snob and a racist (there are extremely distasteful anti-semitic passages in *A Human Document* itself). He has however been the subject of some praise from A. J. Ayer for his philosophical dialogue *The New Republic*, and *A Human Document* itself is flatteringly mentioned in a novel by Dorothy Richardson. However, for what were to become my purposes, his book is a feast. I have never come across its equal in later and more conscious searchings. Its vocabulary is rich and lush and its range of reference and allusion large. I have so far extracted from it over one thousand texts, and have yet to find a situation, statement or thought which its words cannot be adapted to cover. To cite an example (and one that shows how Mallock can be made ironically to speak for causes against his grain); I was preparing for an exhibition in Johannesburg (May 1974) and wanted to find some texts to append to paintings; I turned (as some might do to the *I Ching*) to *A Human Document,* and found, firstly: –

wanted. a little white opening out of thought.

* Paris Review. Fall 1965.

and secondly: –

delightful the white wonder
to have the sport and grasses.
The ancient dread
judgement now has come
judgement suddenly. black from a distance.
expected, hurrying on.

Take a new turn
back to reason.

More recently, in working on an illustrated edition of my own translation of Dante's *Inferno* I have managed to find a hundred or so parallel texts from *A Human Document* which act as a commentary to the poem. I have even found sections of blank verse to match the translation as in this fragment which forms the half-title: –

My stories of a soul's surprise, a soul
which crossed a chasm in whose depths I find
I found myself and nothing more than that.

When I started work on the book late in 1966, I merely scored out unwanted words with pen and ink. It was not long though before the possibility became apparent of making a better unity of word and image, intertwined as in a mediaeval miniature. This more comprehensive approach called for a widening of the techniques to be used and of the range of visual imagery. Thus painting (in acrylic gouache) became the basic technique, with some pages still executed in pen and ink only, some involving typing and some using collaged fragments from other parts of the book (since a rule had grown up that no extraneous material should be imported into the work).

Much of the pictorial matter in the book follows the text in mood and reference: much of it also is entirely non-referential, merely providing a framework for the verbal statement and responding to the disposition of the text on the page. In every case the text was the first thing decided upon: some texts took years to reach a definitive state, usually because such a rich set of alternatives was present on a single page and only rarely because the page seemed quite intractable. In order to prove (to myself) the inexhaustibility of even a single page I started a set of variations of page 85: I have already made over twenty.* The visual references used range from a telegram envelope to a double copy of a late Cézanne landscape.

* some of which have already been published in *A Humument Supplement* (Tetrad Press), *OU* magazine, and *Six variations* (Coriander Press).

The only means used to link words and phrases are the "rivers" in the type of the original; these, if occasionally tortuous, run generously enough and allow the extracted writing to have some flow so that it does not become (except where this is desirable) a series of staccato bursts of words.

Occasionally chance procedures have been used. One page (p. 99) executed in this way was first divided into half, and, by tossing coins, every word except one was eliminated from each half. Once again the book spoke (like the *I Ching*). Its two words, in a faintly Jewish voice, said (in 1967) "something already". The title itself was arrived at by invited accident: folding one page over and flattening it on the page beneath makes the running title read A HUMUMENT, (i. e. A HUM(AN DOC)UMENT), which had an earthy sound to it suitable to a book exhumed from, rather than born out of, another.

The numerical order of the pages is not the chronological order of their making. The initial attack on the book was made by taking leaves at random and projecting the themes that emerged backwards and forwards into the volume. In the end the work became an attempt to make a *Gesamtkunstwerk* in small format, since it includes poems, music scores, parodies, notes on aesthetics, autobiography, concrete texts, romance, mild erotica, as well as the undertext of Mallock's original story of an upper-class cracker-barrel philosopher, ex-poet and diplomat, who falls in love with a sexy prospective widow from Hampstead (her husband is out of combat, being a sick man, and, being a Jew, beyond the pale in any case).

Many rules have grown up in the course of the work. Although Mallock's original hero (Grenville) and heroine (Irma) have their parts to play, the central figure of this version is Bill Toge (pronounced "toe-dj"). His adventures can only (and must) occur on pages which originally contained the words "together" or "altogether" (the only words from which his name can be extracted). He also has his own recurrent iconography; his insignia include a carpet and a window looking out onto a forest and his amoeba-like ever-changing shape is always constructed from the rivers in the type. His story, the Progress of Love, is a favourite neo-platonic *topos* and there are deliberate parallels with the *Hypnerotomachia Polophili*, the most beautiful of printed books, published in Venice in 1499.

As well as *A Humument* itself, Mallock's novel has been the source for other ventures, notably the complete score of an opera IRMA* whose libretto, music, staging instructions and costume designs all come from *A Human Document*. This received its first performance in Newcastle in 1973 which was followed by a performance at York University in the same year and has recently been recorded in a version devised by Gavin Bryars (Obscure Records). Other offshoots include *Trailer* (published by edition hansjörg mayer, Stuttgart 1971) which is in

* first published in OU magazine 1970 and reprinted by the Tetrad Press in 1972, and by the artist in 1978 in conjunction with Waddington Graphics as a silkscreen print.

effect garnered from the cutting floor of *A Humument,* though a self-sufficient work, and *DOC,* a series of affidavits and testimonies which attempt to build up the picture of a lecherous doctor. There exists also a large number (about three hundred to date) of self-contained fragments, small paintings which make variations of wording and design from the book itself and catch up on some lost opportunities in the original. Texts from the same Mallock novel also appear as pendants to paintings such as the series *The Quest for Irma* (1973) and *Ein Deutsches Requiem: after Brahms.* In preparation is a ballet scenario (with score and costume designs) which could either be performed separately (as *The Quest for Grenville*) or as an interlude in performances of *IRMA.*

As work went on and ramified, a second copy of *A Human Document* became necessary. Curiously enough it turned up in the other branch of the same furniture repository (though this time it cost 1/6d). This copy had belonged to one Lottie Yates who had herself "treated" it to some extent, heavily underlining passages that seemed to relate to her own romantic plight (occasionally in the margin she had sighed "How true!"). It seems also that she had used it as a means of saying to her beloved the things she lacked words for, passing the underlined copy to him as a surrogate love letter. Thus, in 1902, someone had already started to work the mine. The first copy had belonged to a Mr Leaning and was unmarked save for his signature. I have since acquired twelve copies. Most have no sign of their owners: one, however, which was purchased at the Beresford Library, Jersey, in 1893, by Colonel J. K. Clubley, passed eventually into the hands of someone who merely signs himself "Hitchcock". The most recent addition has been a copy supplied by a well-wisher from the library of Sir Gerald Kelly, a past president of the Royal Academy, though how he got if from "Nell" to whom it was presented by "Michael" in 1901 is not recorded.

I have so far used up seven copies of the novel to make *A Humument* and its derivatives; I am now well into an eighth. I have yet to find a copy of the original three-decker first edition which I would greatly like to work on.* To help me locate certain key words (when tackling the Dante project for example) I have, with some help from others, compiled a complete concordance to *A Human Document.*

All the work on *A Humument* has been done in the evenings so that I might not, had the thing become a folly, regret the waste of days. One kind of impulse that brought this book into slow being was the prevailing climate of textual criticism. As a text, *A Humument* is not unaware of what then occupied the pages of *TelQuel* (and by now must already have become a feature of undergraduate essays). Much of structuralist writing tends to be the picking over of dead words

* If any reader knows of one for sale, or indeed of any further copy of the popular edition I should be grateful for the information.

to find sticks for the fires of cliqueish controversy. *A Humument* exemplifies the need to "do" structuralism, and, (as there are books both *of* and *on* philosophy) to be *of* it rather *on* it. At its lowest it is a reasonable example of *bricolage,* and at its highest it is perhaps a massive *déconstruction* job taking the form of a curious un-witting collaboration between two ill-suited people seventy five years apart. It is the solution for this artist of the problem of wishing to write poetry while not in the real sense of the word being a poet . . . he gets there by standing on someone else's shoulders.

Publication of *A Humument* was started in 1970 by the Tetrad Press with a box of ten silkscreened pages which made up Volume 1. Other volumes (ten in all, containing varying quantities of pages) were printed by lithography, silk-screen, and letterpress in a limited edition of one hundred copies. The original manuscript was completed in the autumn of 1973 and was shown within days of that event, in its entirety, at the Institute of Contemporary Arts (in whose bulle-tin, then edited by Jasia Reichardt, it was first mentioned in 1967).

This first edition in book form differs from the private press edition in that several new pages have been substituted for the first versions and many other pages have been reworked by hand, using the advantages of revision offered by the preparatory stages for colour offset lithography. If this book finds favour (i. e. sells), and I live, the consequent reprints will allow me to replace say a dozen pages with each new edition. A notional thirtieth (!) printing therefore would be an entirely reworked book with almost no pages surviving from the first.

In a sense, because *A Humument* is *less* than what it started with, it is a para-doxical embodiment of Mallarmé's idea that everything in the world exists in order to end up as a book.

T. P. 1980. This is a revised version of the Notes printed in Works/Texts to 1974 (Edition Hansjörg Mayer) which were themselves adapted from an article in the London Magazine in 1971.